John

Constable

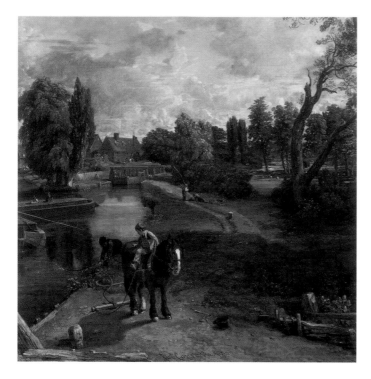

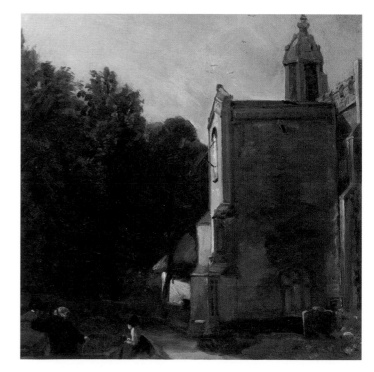

© 2005 Sirrocco, London, UK (English version)
© 2005 Confidential Concepts, worldwide, USA

ISBN 1-84013-760-6

Published in 2005 by Grange Books
an imprint of Grange Book Plc
The Grange Kingsnorth Industrial Estate
Hoo, nr Rochester, Kent ME3 9ND
www.Grangebooks.co.uk

Printed in China

John
Constable

Grange BOOKS

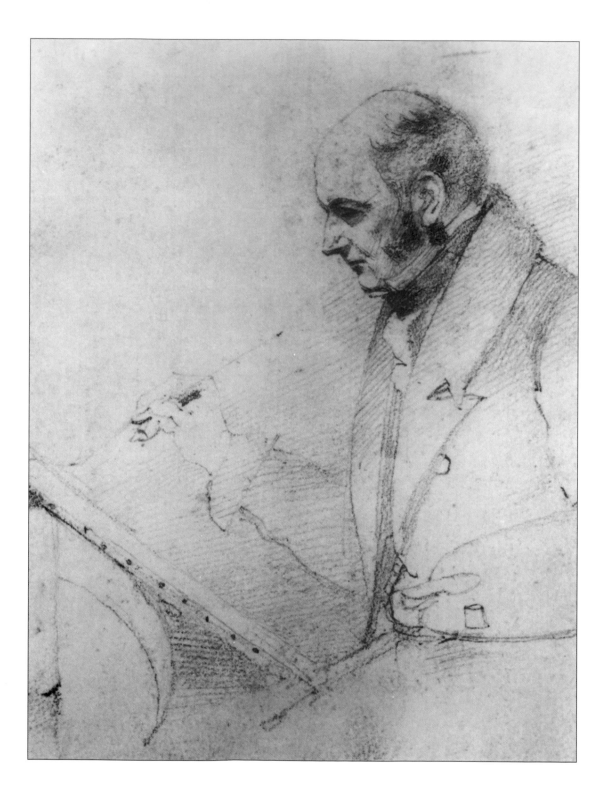

John Constable is arguably the best-loved English artist. His fame and popularity are rivalled only by those of his great contemporary, J. M. W. Turner. But like Turner, his reputation rests on a handful of very well-known paintings, normally Suffolk scenes such as *Flatford Mill* (p. 35) or the *Hay-Wain* (p. 48). The latter in particular is so famous that it sometimes overshadows the rest of his work, whereas we know from Constable's writings that he set greater store by his *Stratford Mill*, and once declared that it was *Salisbury Cathedral, from the Meadows* (p. 71) rather than the *Hay-Wain* which best embodied 'the full compass' of his art. For all its fame, even the *Hay-Wain* itself is misunderstood. It is so familiar that it is hard for a modern spectator to grasp the enormous impact it had upon some of the greatest French painters of the day. In order fully to appreciate Constable's achievement, one must first attempt to clear away some of the many misconceptions surrounding his work.

He was, for example, a more versatile artist than most of his modern admirers realise. It is true that he was deeply and sentimentally attached to the scenery of Suffolk, and unlike many of his colleagues he did not normally tour in search of material; but his friendships and family life forced him to travel, and so there is diversity in his subject matter, embracing the Lake District, Hampstead, Kent, Dorset, Sussex and Salisbury. Many of the magisterial productions of his last years, including *Hadleigh Castle* and *The Opening of Waterloo Bridge* (p. 74) are a far cry from the Suffolk scenes, whilst his accomplishments within the difficult and competitive genre of marine painting have been consistently undervalued.

A persistent error surrounding Constable's work is that it is somehow 'artless' and untouched by theory – that he simply 'painted what he saw' in response to the beauty of the English countryside. On the contrary, he was a sophisticated, reflective artist whose naturalism was hard-won, based on an incessant study of nature, the Old Masters and wide reading. Far from disdaining theory, Constable's library is known to have contained an enormous body of theoretical texts, ranging from classic writings by Cennino Cennini, Leonardo da Vinci, Roger de Piles and Gerard de Lairesse, to the more recent works of Sir Joshua Reynolds and Henry Fuseli. Where landscape was concerned, there were few important books that escaped his notice, and he had a thorough mastery of the aesthetic debates which preoccupied his contemporaries. Late in life he even lectured on the subject himself. He was also well versed in science, poetry, history and divinity, and like Turner, he put this fund of self-acquired knowledge to use in his paintings. In short, the breadth of his intelligence and the clarity of his ideas are seriously at odds with the view of Constable as a naïve realist.

1. Daniel Maclise, *Constable painting*, c.1831, Pencil sketch, 15 x 11.5 cm, National Portrait Gallery, London.

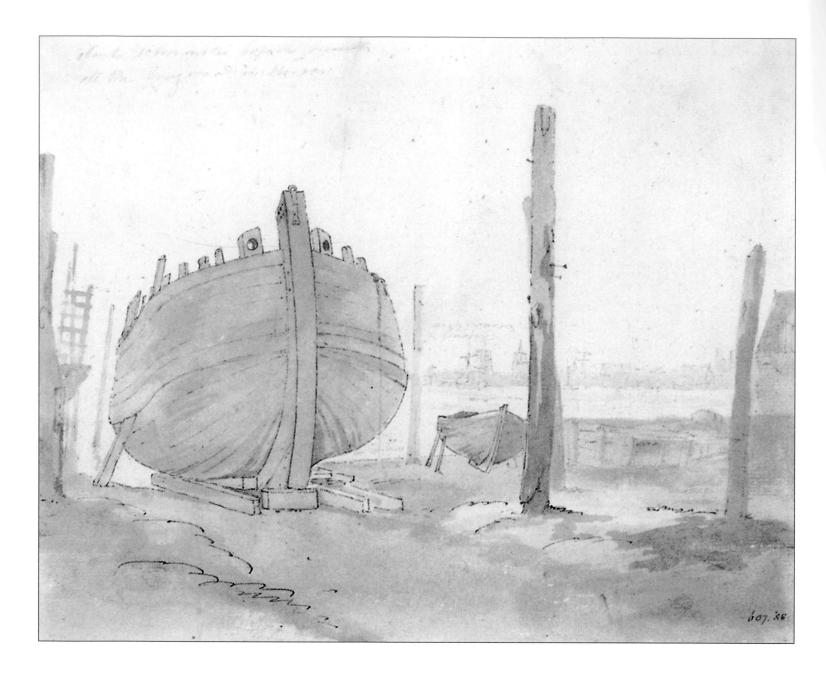

It is also tempting to forget that Constable was a professional painter, and that the kind of success and reputation he desired could only be achieved in London within the orbit of the Royal Academy. He could have earned a living in Suffolk, just as his contemporary, John Crome, was able to do in Norwich; but Crome relied for a steady income upon his work as a drawing master whereas Constable looked for a professional status that would match his family's social position.

Constable had a very high-minded view of landscape and was single-minded in pursuing his own course, but he also craved recognition and tried various strategies to secure it: he increased the scale of his pictures, occasionally varied his subjects and sometimes tailored his paintings to meet the expectations of the Royal Academy. He had an independent income, but it was not enough to support his family, and he was therefore sometimes compelled to sell duplicates of his most successful scenes and to accept uncongenial commissions. These conflicts between his declared intentions, professional ambitions and family responsibilities are fundamental to an understanding of Constable's career.

2. *Riverside*; *ship against the sunset*, c. 1800, Pen, ink and grey wash drawing, 20.1 x 25.2 cm, Victoria and Albert Museum, London.

3. *Incised Outline of a Windmill*, fragment of the windmill on East Bergholt Heath, 1792, Incised in wood, 29.5 x 39.5 cm, The Minories, Colchester.

John Constable was born in East Bergholt, Suffolk, on June 11, 1776, the fourth child and second son of Ann and Golding Constable. His father was a prosperous local corn merchant. His family's business interests provided Constable with the allowance which supplemented his meagre income as a painter, and, equally important, with a repertoire of familiar subjects. 'Constable Country', as it is now known, comprises only about twelve square miles of the Stour Valley on the Suffolk-Essex border. Around 1833, in a text intended to accompany an engraving of the house in which he was born, Constable described East Bergholt as "pleasantly situated in the most cultivated part of Suffolk, on a part which overlooks the fertile valley of the Stour. The beauty of the surrounding scenery, the gentle declivities, the luxuriant meadow flats sprinkled with flocks and herds, and well cultivated uplands, the woods and rivers, the numerous scattered villages and churches, with farms and picturesque cottages, all impart to this particular spot an amenity and elegance hardly anywhere else to be found." But, as he also confessed, the landscape evoked memories for him that his audience could not share: it had witnessed "the happy years of the morning of his life," and later, as he grew to maturity, it became the place where "he early met those, by whose valuable and encouraging friendship he was invited to pursue his first youthful wish" to become a painter. He believed that the landscape, its beauties and its associations with his "careless boyhood", had made him a painter. As if to emphasize his point, Constable introduced into the engraving of his parents' house an artist sketching in the open air.

Constable became increasingly nostalgic for his "careless boyhood" as his anxieties and responsibilities grew. He received most of his education at Dedham Grammar School, where according to his biographer, C. R. Leslie, he distinguished himself more by his draughtsmanship than his scholarship. His father probably intended him to become a clergyman – a respectable and lucrative profession – but John's halfhearted attitude to his studies gave him second thoughts. He decided in 1793 to train him as a miller instead, but by this time Constable had developed a keen enthusiasm for painting.

His closest friend at this time was John Dunthorne, the local plumber, glazier and village constable. Dunthorne's devotion to landscape painting matched that of Constable, and he probably instilled in the younger man an early enthusiasm for outdoor study. David Lucas, Constable's engraver, described them as "very methodical in their practice, taking their easels with them into the fields and painting one view only for a certain time each day. When the shadows from objects changed, their sketching was postponed until the same hour next day." Constable and Dunthorne eventually became estranged, partly because the latter was highly unconventional (he and his wife had married through a newspaper advertisement) and a known atheist.

4. *Dedham Church and Vale*, 1800, Pen, ink and watercolour, 34.6 x 52.7 cm, Whitworth Art Gallery, University of Manchester.

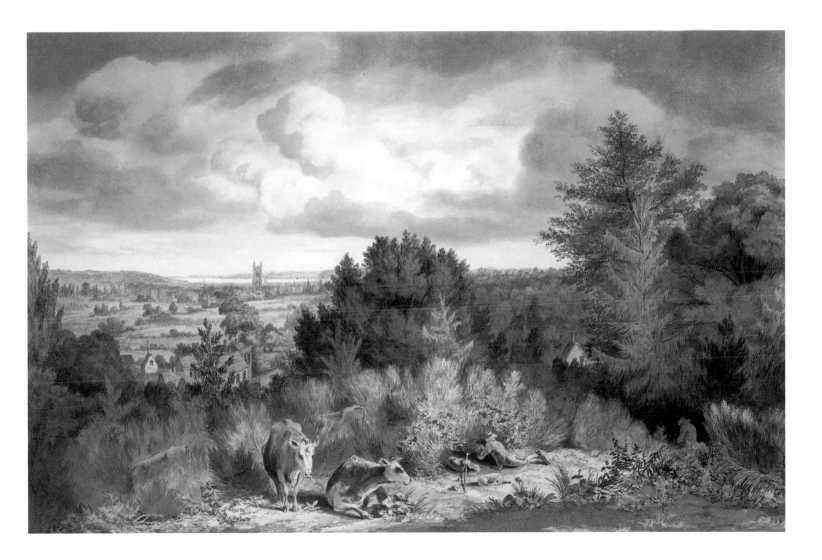

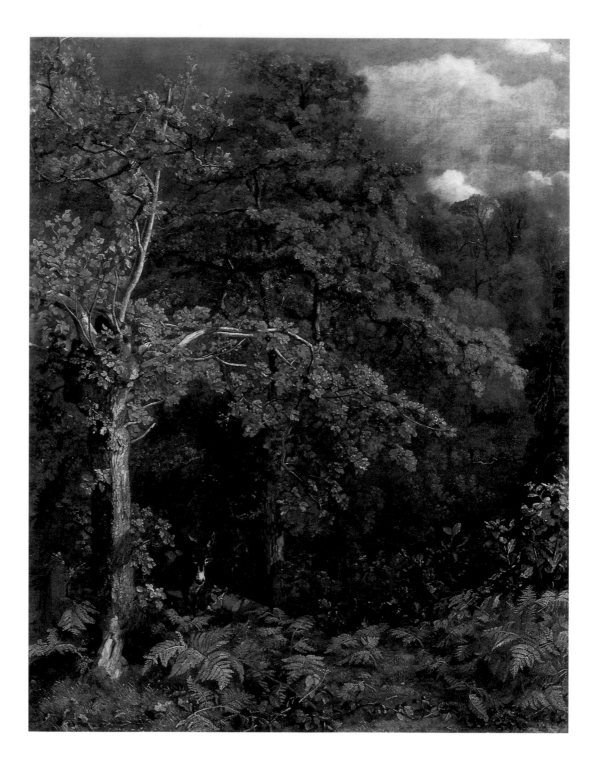

5. *Edge of a Wood*,
1801-1802,
Oil on canvas,
92.1 x 72.1 cm,
Appleton Museum
of Art, Ocala.

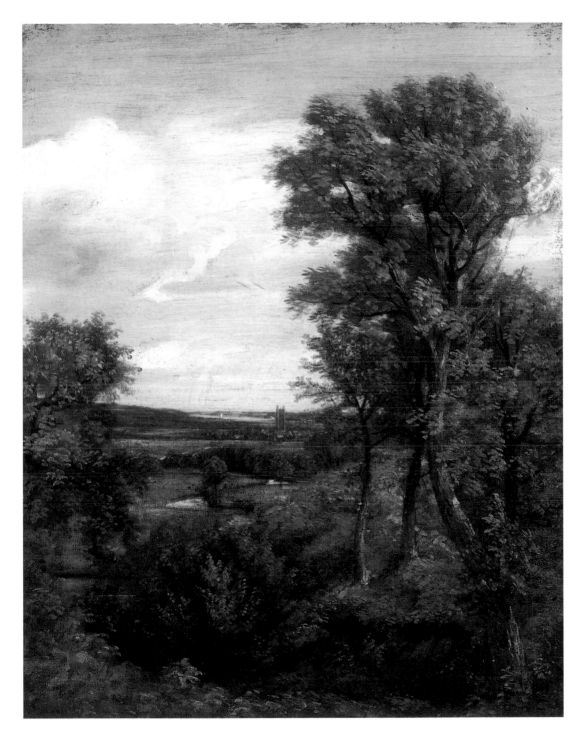

6. *Dedham Vale,* 1802,
 Oil on canvas,
 43.5 x 34.4 cm,
 Victoria and Albert
 Museum, London.

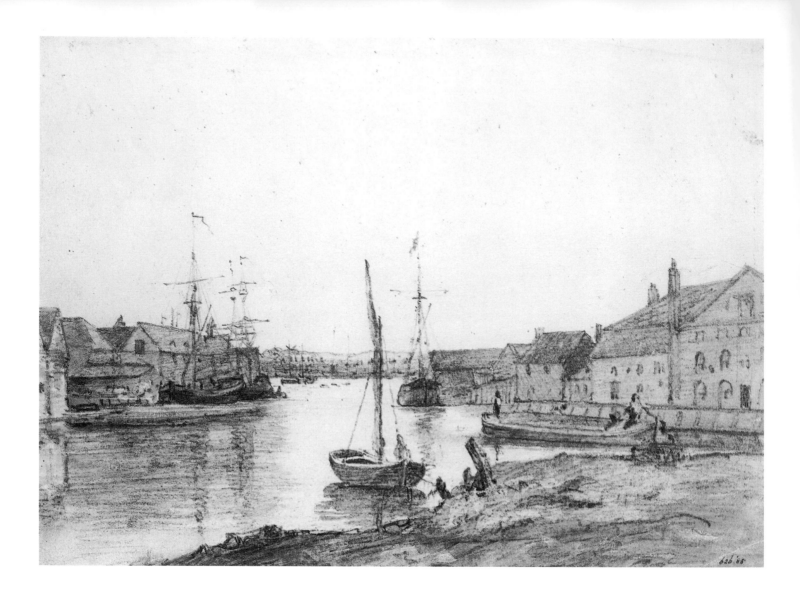

7. *Warehouses and
Shipping on the Orwell
at Ipswich,* 1803,
Watercolour and
pencil, 24.5 x 33.1 cm,
Victoria and Albert
Museum, London.

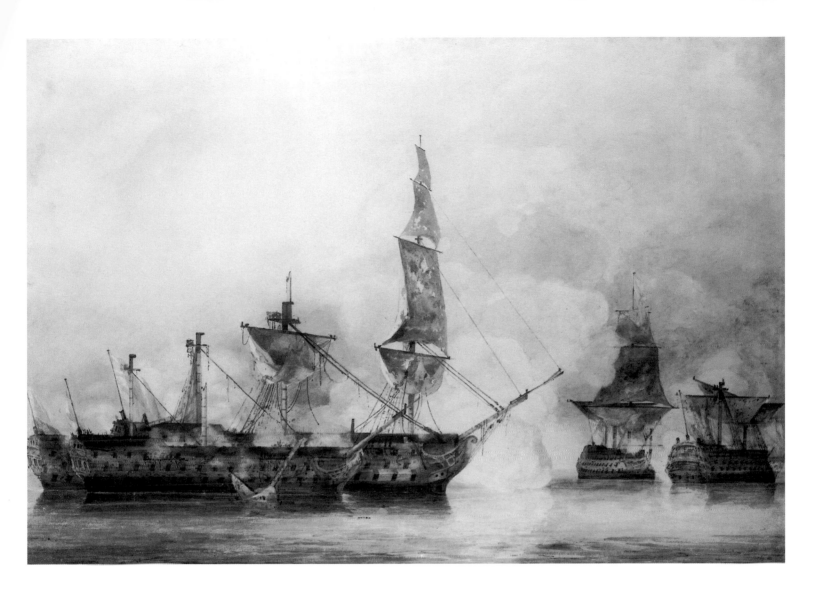

8. *His Majesty's Ship
 "Victory"*, *Capt. E. Harvey,
 in the memorable Battle of
 Trafalgar between two
 French Ships of the Line*,
 1806, Watercolour,
 51.6 x 73.5 cm,
 Victoria and Albert
 Museum, London.

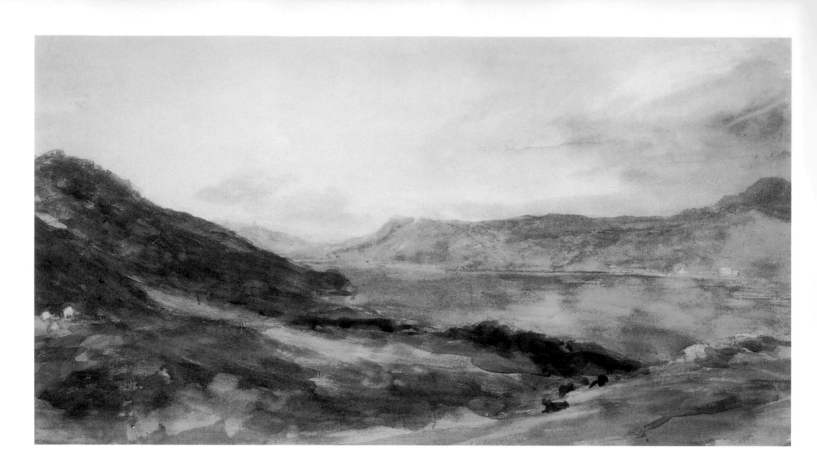

9. *Windermere*, 1806,
Pencil and watercolour,
20.2 x 37.8 cm,
Fitzwilliam Museum,
Cambridge.

His friendship would have been a severe embarrassment to the artist when he was courting the local rector's granddaughter. In the late eighteenth and early nineteenth centuries, the education of an aspiring artist was provided only partly by the official teaching institutions. Constable, like many of his peers, attended the Royal Academy Schools, where he was taught to draw correctly from prints, plaster casts and life. There were serious shortcomings to this approach. Young artists heard lectures on ancient history, literature, anatomy and the theory of painting, but were offered no systematic training in the use of oils until 1819. Aspiring landscapists were particularly disadvantaged.

The training offered at the Royal Academy was directed towards the production of history painters; there was no tuition that was relevant to landscape art as such. It was up to the artists themselves to supplement the Royal Academy's teaching by informal means, hence the overwhelming importance of Constable's earliest friends and mentors. In 1796, Constable was staying with his mother's relatives, the Aliens, at Edmonton, where he was introduced to John Thomas Smith, teacher, artist, writer and antiquarian. 'Antiquity Smith', as he was known, enjoyed a modest fame as a biographer, but he was

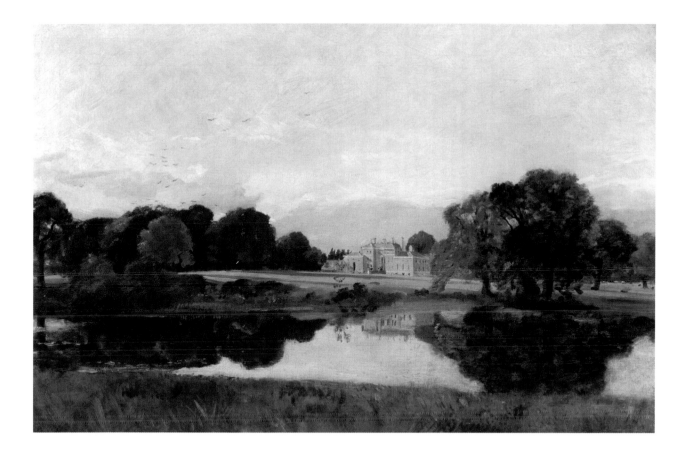

also well versed in the theory of landscape and published his own slight contribution, *Remarks upon Rural Scenery,* in 1797. Constable helped to collect subscriptions for the book, whilst Smith, together with his friend, the painter John Cranch, took charge of the young man's education. Cranch provided him with a list of the reading he considered indispensable for an artist, together with valuable study hints; Smith confirmed him in his love for humble domestic scenery and schooled him in the excellences of Thomas Gainsborough.

Smith also performed one other great service for Constable: in 1798 he finally persuaded Golding Constable to allow his son to pursue a career as a painter. The practice of open-air painting, which developed through the work with Dunthorne, was reinforced by Constable's meeting in 1797 with George Frost, an amateur artist much older than Constable, but with a solid local reputation. Frost loved the Suffolk landscape, and he also possessed a detailed knowledge of the work of Gainsborough. But at this stage he was very selective where Gainsborough was concerned, and only gave his - whole-hearted approval to early naturalistic scenes such as *Cornard Wood*, a picture that was eventually purchased by his maternal uncle, David Pike Watts.

10. *Malvern Hall Warwickshire*, 1809, Oil on canvas, 51.5 x 76.9 cm, Tate Gallery, London.

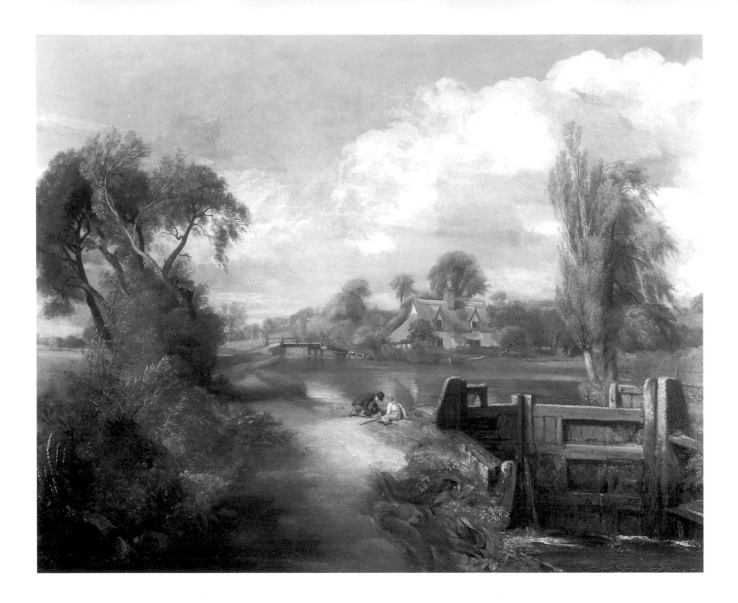

11. *Landscape: Boys
Fishing*, 1813,
Oil on canvas,
101.6 x 125.8 cm,
National Trust,
Fairhaven Collection,
Anglesea Abbey.

12. *East Bergholt Church*,
1811, Watercolour,
39.7 x 60 cm,
The Lady Lever Art
Gallery, Port Sunlight.

Gainsborough's later works, Constable implied, were too mannered – a judgment he was to revise at a later stage in his career when his own paintings departed from the strict canons of naturalism. The most important of his early mentors was Sir George Beaumont, whom he met in 1795 whilst Beaumont was visiting his widowed mother, who lived in Dedham. Although he had a formidable reputation as a collector and connoisseur, Beaumont had made many enemies in the Royal Academy and has often received a bad press from historians because he was an implacable opponent of Turner's art. He believed that its extravagances would lead young British painters away from nature.

To Constable, however, who had much to learn, Beaumont was generous and encouraging. He showed Constable the *Landscape with Hagar and the Angel* by Claude Lorrain, a work he treasured so much that he carried it with him wherever he journeyed. Its influence is easily discernible in the two versions of *Dedham Vale* (p. 11 and 54) which span a quarter-century of Constable's working life. Beaumont's importance extended beyond the glories of his collection, for he was also an accomplished amateur painter who exhibited his work at the Academy. In fact he could offer practical advice. Farington was the means through which Constable entered the Academy Schools. Farington told him that "he must prepare a figure" as a demonstration of his competence, and having done so, Constable was admitted as a probationer to the Royal Academy Schools and properly registered in the following year.

Constable's earliest experiences in London, as he confided them to Dunthorne, were rather mixed. He rejoiced in the collections of Old Master paintings to which he now had access, and even told his friend that "I find my time will be more taken up in *seeing* than in painting." But it was productive research and he regularly made new discoveries. His personal and social life were less satisfactory. He was often homesick, once confessing to Dunthorne that "This fine weather almost makes me melancholy; it recalls so forcibly every scene we have visited and drawn together."

Constable's early work was unremarkable, but West, like Farington, must have found a spark of promise for in 1802 he persuaded Constable to refuse an offer of secure employment as a military drawing master. Unless he had real faith in the young man's potential, it would have been cruel and irresponsible advice. The Royal Academy was thoroughly imbued with the doctrines and posthumous influence of Sir Joshua Reynolds, its first president. Constable celebrates Reynolds's formative role in the development of a British school of painting in *The Cenotaph* (p. 79) of 1836. The notion that there was a hierarchy of subject-matter (or an aristocracy, as Cranch put it) was fundamental to academic teaching until well into the nineteenth century.

13. *Ann and Mary Constable*,
c. 1810-1814,
Oil on canvas,
90 x 69.5 cm,
Trustees of the
Portsmouth Estates.

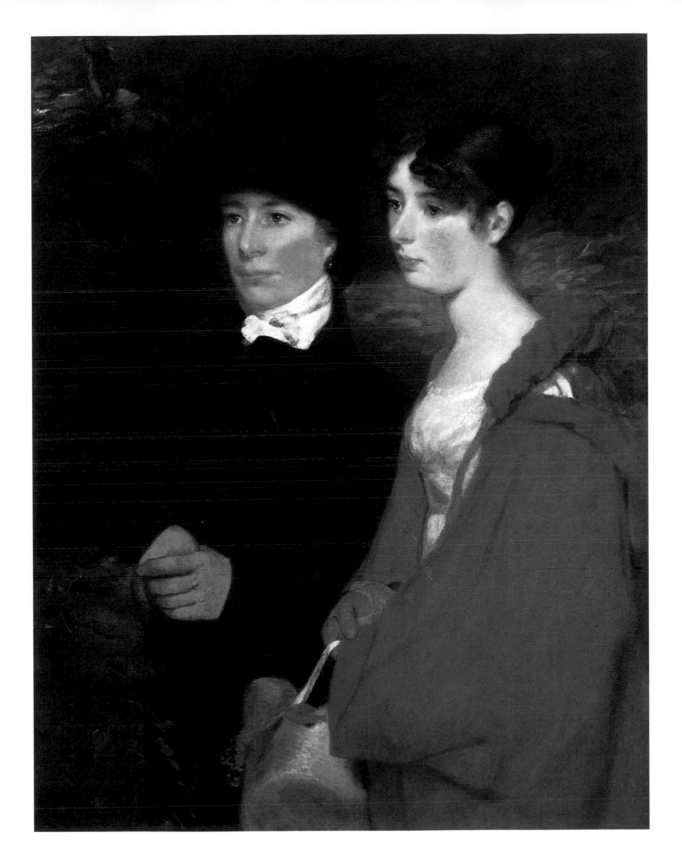

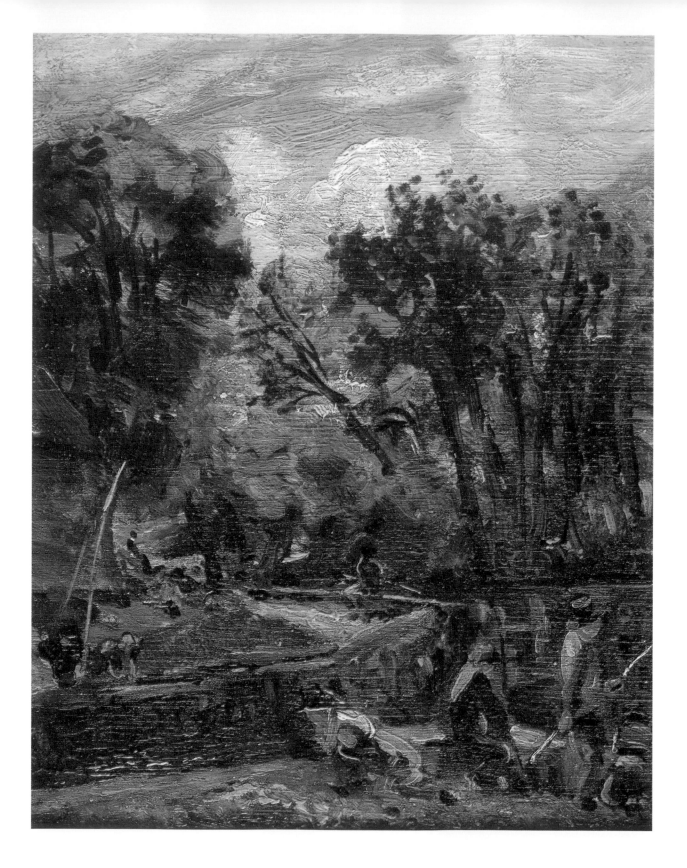

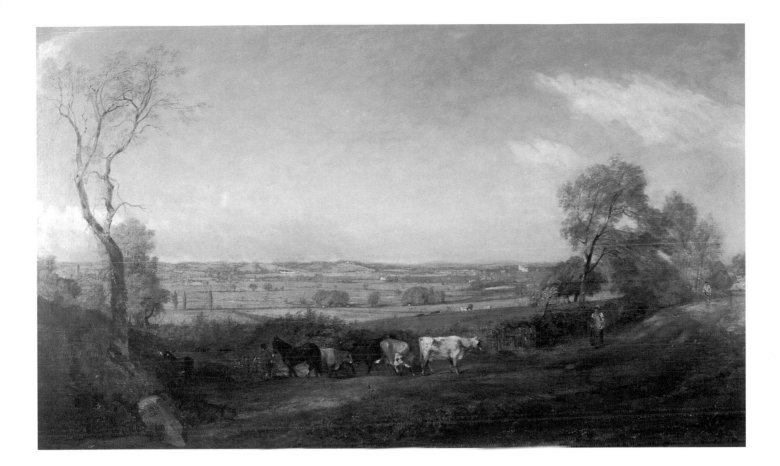

Historical paintings were granted a higher status than portraits, whilst portraiture in turn was considered a more dignified form than landscape. The most ambitious landscape painters of the day, such as Constable and Turner, were not content to see their chosen art treated as an inferior genre. They attempted, in different ways, to show that landscape might possess the intellectual and moral range normally attributed only to history paintings. As a painter of grand historical landscapes, Turner's genius was quickly acknowledged, but in Constable's case it was a long, hard struggle, because, as C. R. Leslie pointed out, he worked within "the humblest class of landscape", depicting what Cranch referred to as "*Familiar* nature". Ideal landscapes also took precedence over the faithful representation of rural scenes to which Constable was committed. The conviction that there was a moral dimension to landscape painting remained with Constable all his life. It gave him the satisfaction of attributing his lack of recognition to the moral inadequacy of his contemporaries, but above all it subverted the academic hierarchy of subject-matter. For the first time in 1802, Constable had a work accepted for the Royal Academy's exhibition.

14. Study for *Stratford Mill*, 1811,
Oil on wood,
18.3 x 14.5 cm,
Private collection.

15. *Dedham Vale: Morning*, 1811,
Oil on canvas,
78.8 x 129.5 cm,
Private collection.

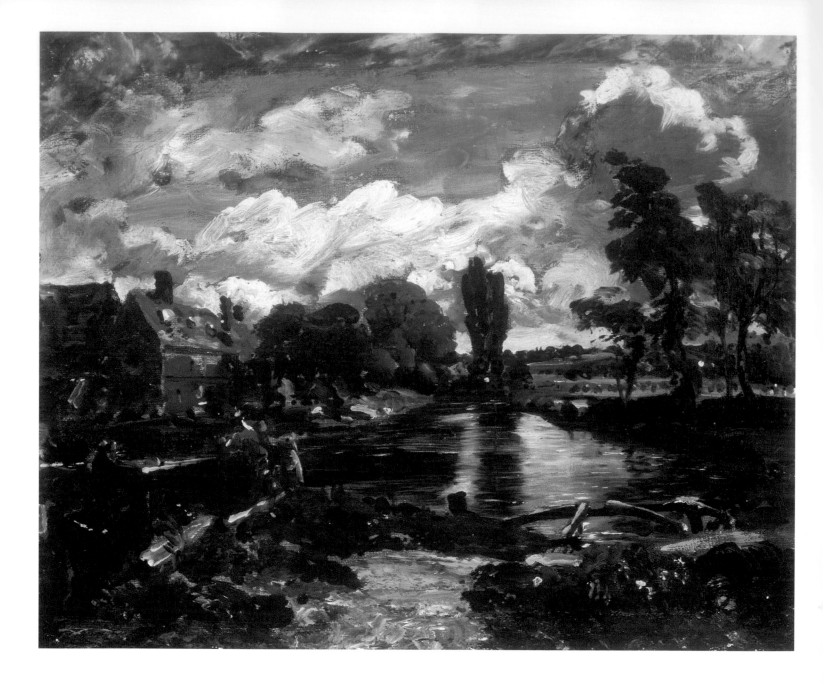

16. *Flatford Mill from the
Lock,* c. 1811, Oil on
canvas, 24.8 x 29.8 cm,
Victoria and Albert
Museum, London.

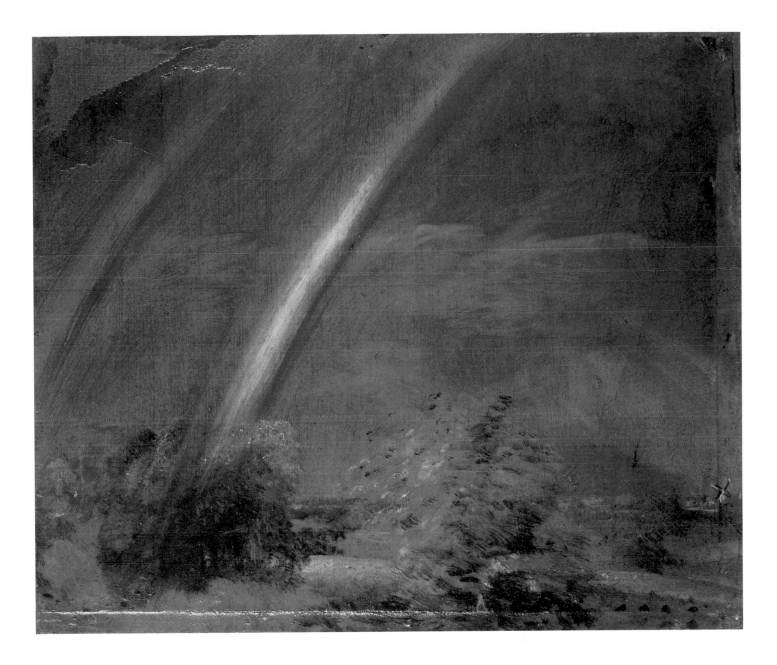

17. *East Bergholt Mill with a double rainbow*, 1812, Oil on paper laid on canvas, 45 x 50 cm, Victoria and Albert Museum, London.

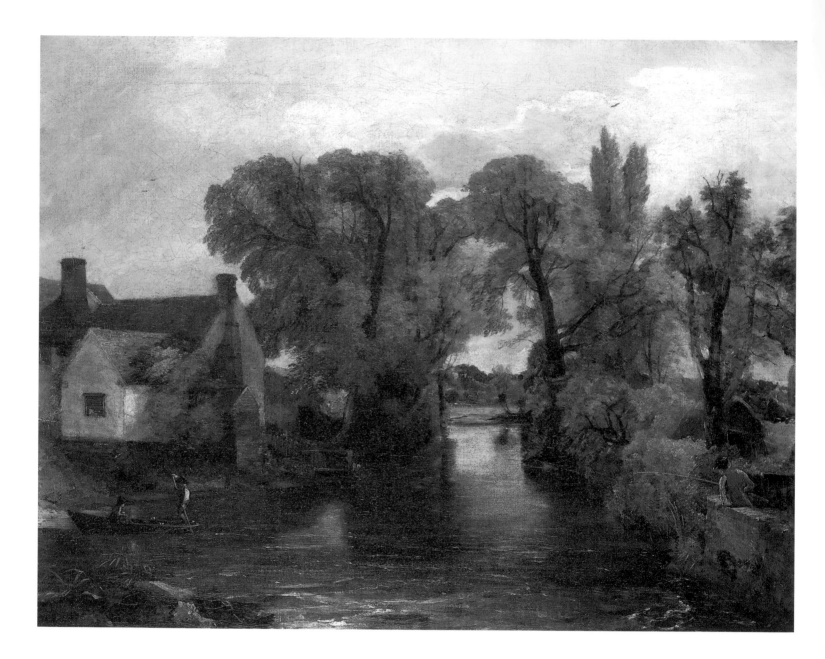

On the strength of his one exhibit, he was severely critical of the rest of the work on show, telling Dunthorne: "There is little or nothing in the exhibition worth looking up to — there is room enough for a *natural painture*. The great vice of the present day is bravura, an attempt at something beyond the truth. In endeavouring to do something better than well they do what in reality is good for nothing. *Fashion* always had, and always will have its day — but *Truth* (in all things) only will last and can have just claims on posterity." Constable's search for "a *natural painture*" (or painting) dominates the first half of his professional life, along with his wish to produce landscape art with a serious moral and intellectual aspect.

The first requirement for a 'natural painter' was a whole-hearted commitment to nature itself, coupled with a cautious approach to the Old Masters. These matters were of more than academic importance for Constable, as he had to strike a balance between art and nature in his own work. In the early watercolour of *Dedham Church and Vale* (p. 9) of 1800, he had serious difficulties resolving his observations of the Suffolk landscape into a harmonious and satisfying picture.

He did so with the example of Claude in mind. The composition of his *Dedham Vale* (p. 54) is successful because it follows Claude's *Landscape with Hagar and the Angel* very closely, but it does so without compromising Constable's close attention to nature. Constable's approach to *plein-air* work was rigourous. Like Turner, he would sketch out of doors in oils, as he did at Flatford between 1810 and 1811, but he frequently went a stage further, attempting as far as possible to complete his pictures before nature. It was a noble ideal but in an era before the invention of tube paints, it was also a difficult and inconvenient one; oil colours prepared beforehand were stored in small sachets of leather or pig's bladder, and when required they were punctured with a pin. To sketch under these conditions was one thing, but to complete an exhibition picture with the required degree of finish and detail was an arduous undertaking.

Nonetheless, finishing from nature remained an important ideal for Constable until perhaps as late as 1816. A more revealing comparison would be between Constable's earlier and later work. In the 1820s, he begins to depart from the strict naturalism of the previous decades; a work like *The Leaping Horse* (p. 62) of 1825 is striking more for the manner in which it is painted than for what it depicts. This is in strong contrast with the younger Constable who sought a *natural painture*, could see no 'handling' in nature and regarded a manner as a vice. The changes which came over his art in the 1820s were brought about by many things, but not least by the fact that he took to his studio.

18. *The Mill Stream,*
 c. 1814,
 Oil on canvas,
 71.1 x 91.5 cm,
 Museums and
 Galleries, Ipswich.

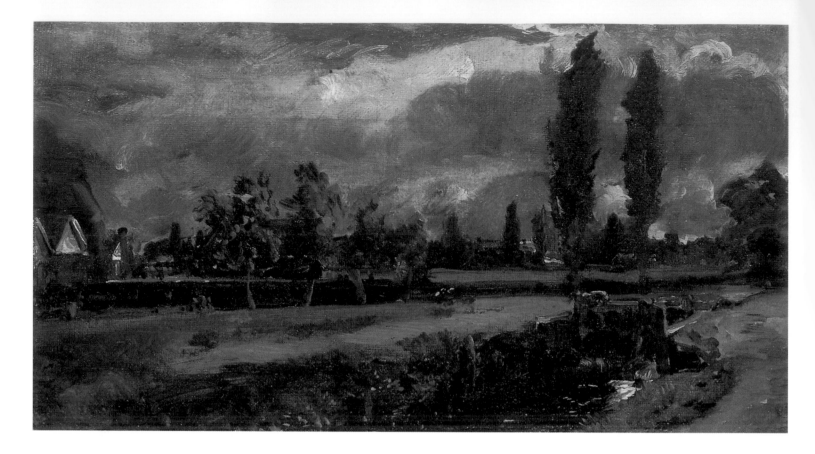

19. *Lock on the Stour,*
 c. 1812-1815,
 Oil on canvas,
 15.9 x 28.6 cm,
 Museum of Art,
 Philadelphia.

20. *A Church porch (The Church Porch, East Bergholt),* c. 1809,
 Oil on canvas,
 44.5 x 35.9 cm,
 Tate Gallery, London.

Constable once praised the Dutch artists of the seventeenth century for being "stay at home" painters, and following their example, he devoted most of his energies in his earlier career to seeking "a pure and unaffected representation" of his native scenery. But there were numerous occasions when he was drawn away from his usual subject-matter. In 1801 he visited Derbyshire to stay with a relative, Daniel Whalley. During his visit he made a sketching tour of the Peak District, taking in the most celebrated beauty spots of the area such as Matlock High Tor and Dovedale. Picturesque touring was virtually *de rigueur* for an ambitious landscape painter, and Constable was prepared at this stage to follow the convention.

Following a pre-arranged itinerary, and depicting *sites* he knew had been visited by countless other artists did not really suit him, although he was persuaded to tour once more in 1806 by his uncle, David Pike Watts. Watts, who fancied himself as a connoisseur, took a keen interest in his nephew's progress. He was generous enough to finance a seven-week trip to the Lake District. The Lakes had become the fashionable haunt of both poets and painters. The Lakeland tour was an important episode in his early career.

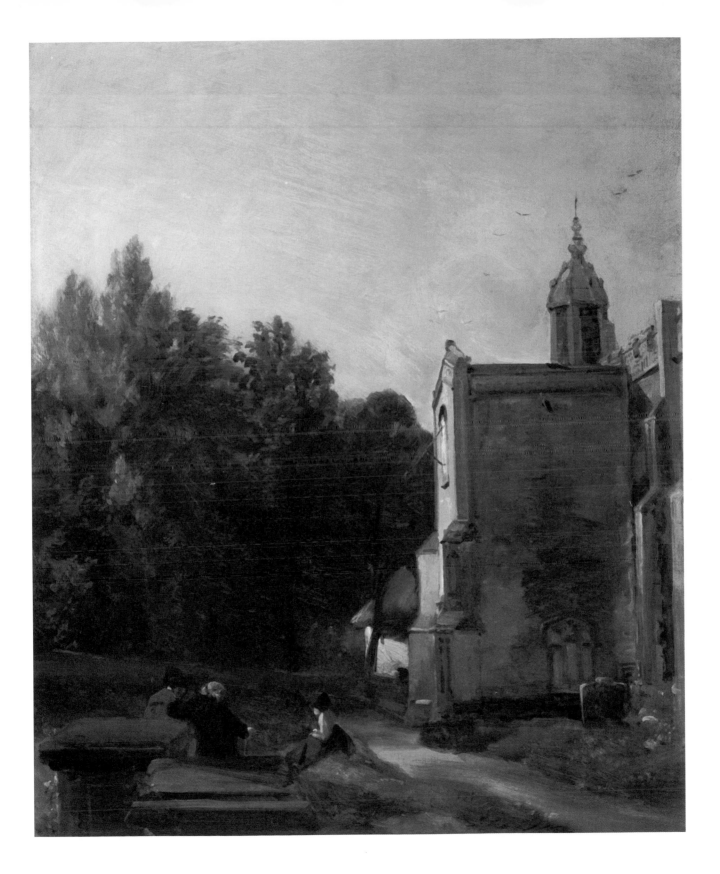

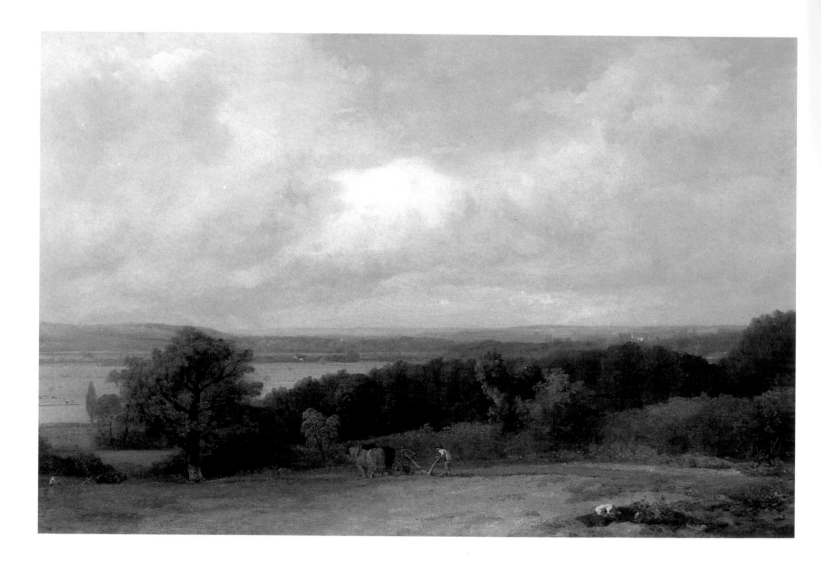

21. *Landscape: Ploughing
 Scene in Suffolk*, 1814,
 Oil on canvas,
 51.4 x 76.8 cm,
 Private collection.

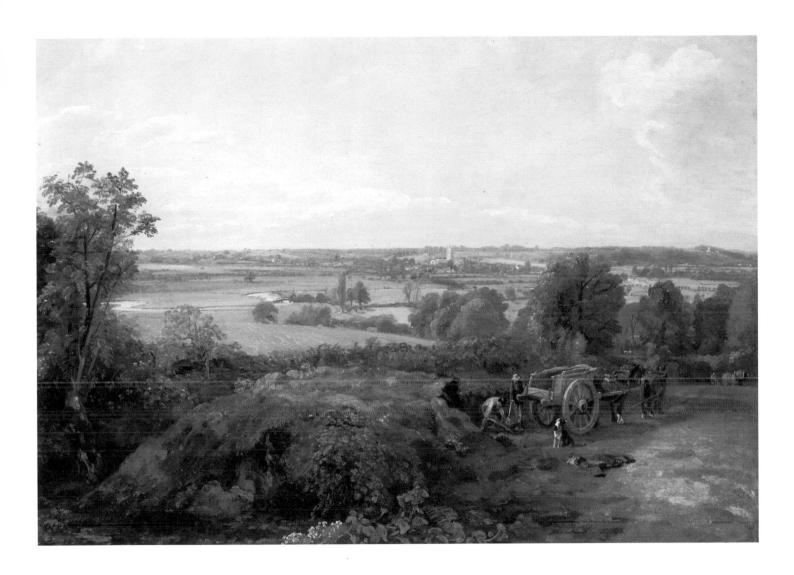

22. *View of Dedham*,
1814, Oil on canvas,
55.3 x 78.1 cm,
Museum of Fine Arts,
Boston.

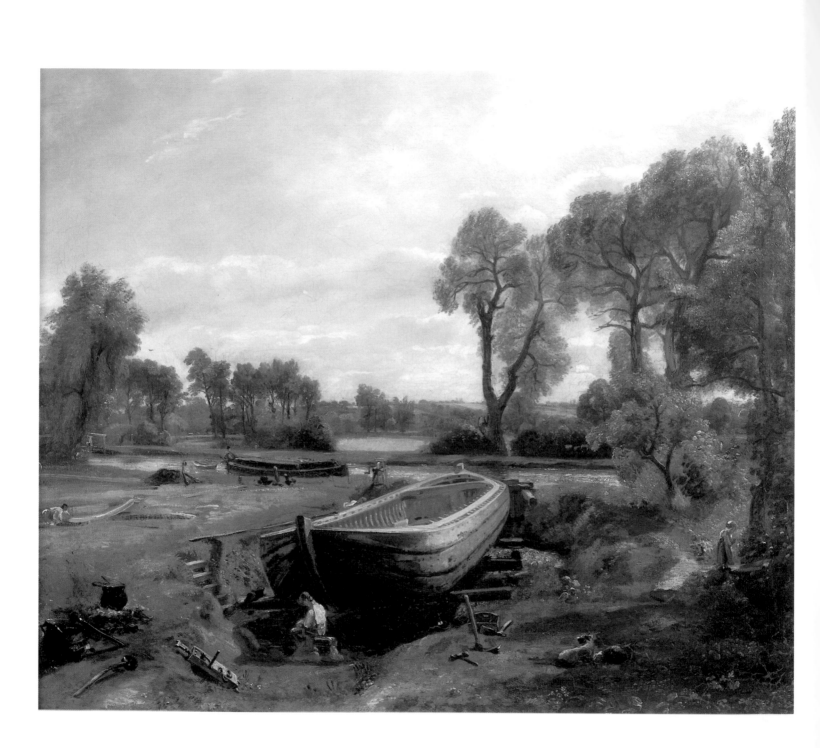

He sketched indefatigably, developed his watercolour technique and learned to respond to unfamiliar terrain and atmospheric conditions. His view of *Windermere* was painted in reasonable weather, but Constable did not allow the unpredictability of the elements to deter him; a sketch of *The Vale of Newlands* (in the Fitzwilliam Museum, Cambridge) was made during a storm and the climatic details inscribed in pencil on the back; others are spotted with rain. Constable hoped that the time and energy he invested in Lakeland would reap a dividend at the Royal Academy.

He showed Lake District scenes there in 1807 and 1808, and prepared a five-foot picture of Borrowdale which Farington thought too unfinished for the exhibition in 1809. Little is now known of these oil paintings, which represents a serious gap in our knowledge since Constable was occupied with them for nearly three years at an important stage in his development. In other respects, his spell in the Lakes was important for widening his circle of patrons (though largely for portraits) and for his meeting with William Wordsworth, another, albeit more famous, protégé of Sir George Beaumont. The Lake District oils were not his only bid for sales and recognition in the first decade of the century.

He made a surprising departure in 1806 by showing a watercolour of *The Battle of Trafalgar* (p. 13). His depiction was highly competent, drawing on a distinguished tradition of English sea battle pictures. But he had no lasting enthusiasm for the genre, and years later dismissed a competition for a painting to commemorate Nelson's victory as irrelevant to his interests. Whilst he was struggling to succeed as a landscape painter throughout the first decade of the century, his meagre income was derived largely from portraiture. Constable's parents were keen for their son to develop a portrait practice since it was known to be more lucrative than landscape, and the most successful portraitists like Reynolds or Lawrence enjoyed both wealth and status. Constable's employment, however, was lowly.

The works he produced on commission, like the group portrait of the Bridges family of 1804 (now in the Tate Gallery), are often highly competent, but portraiture was a competitive business. A rare exception was the portrait of the *Rev. John Fisher*, which was shown in 1817. Fisher was not merely a patron, he was a devoted friend, and his portrait was valued accordingly. On rare occasions Constable entered the field of religious painting and produced altarpieces for Suffolk and Essex churches. The first, *Christ Blessing the Children*, was begun in 1805 for St Michael's Church, Brantham. It was more dignified employment than painting local farmers and their families, and he responded by adapting the style of Benjamin West with details from the Raphael Cartoons.

23. *Boatbuilding*, 1814,
Oil on canvas,
50.8 x 61.6 cm,
Victoria and Albert
Museum, London.

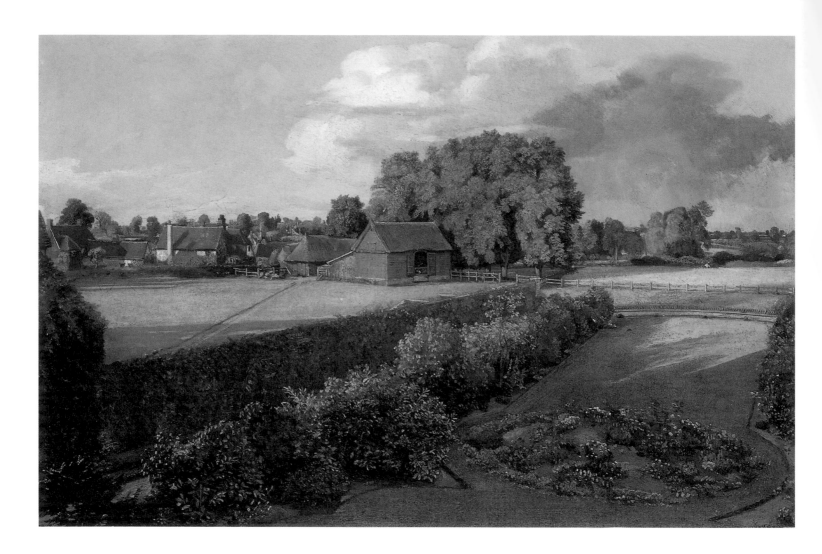

24. *Golding Constable's*
Flower Garden, 1815,
Oil on canvas,
33 x 50.8 cm,
Museums and
Galleries, Ipswich.

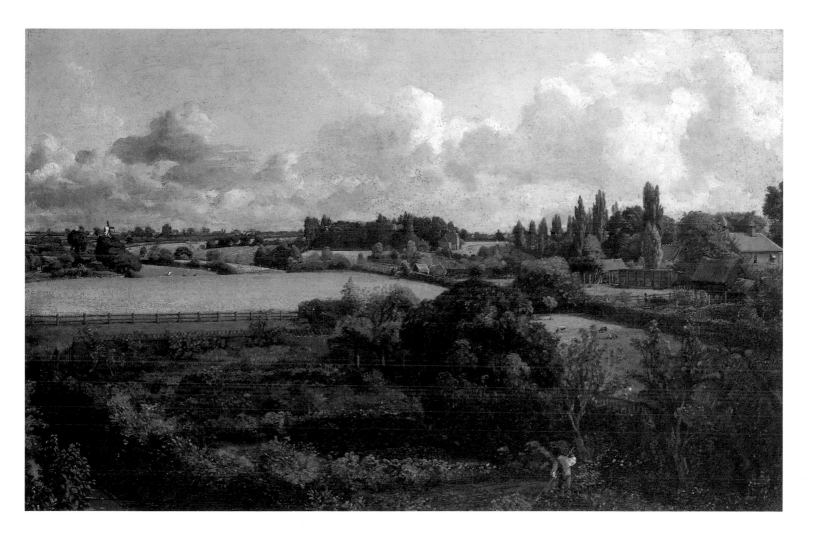

25. *Golding Constable's*
 Kitchen Garden,
 1815, Oil on canvas,
 33 x 50.8 cm,
 Museums and
 Galleries, Ipswich.

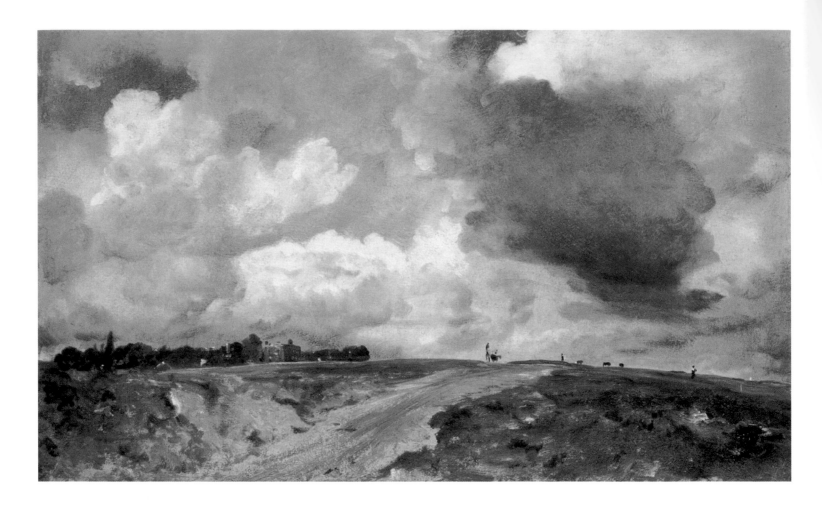

26. *Road to the Spaniards,*
 Hampstead, 1822,
 Oil on canvas, 30.8 x 51.1 cm,
 Philadelphia Museum of Art.

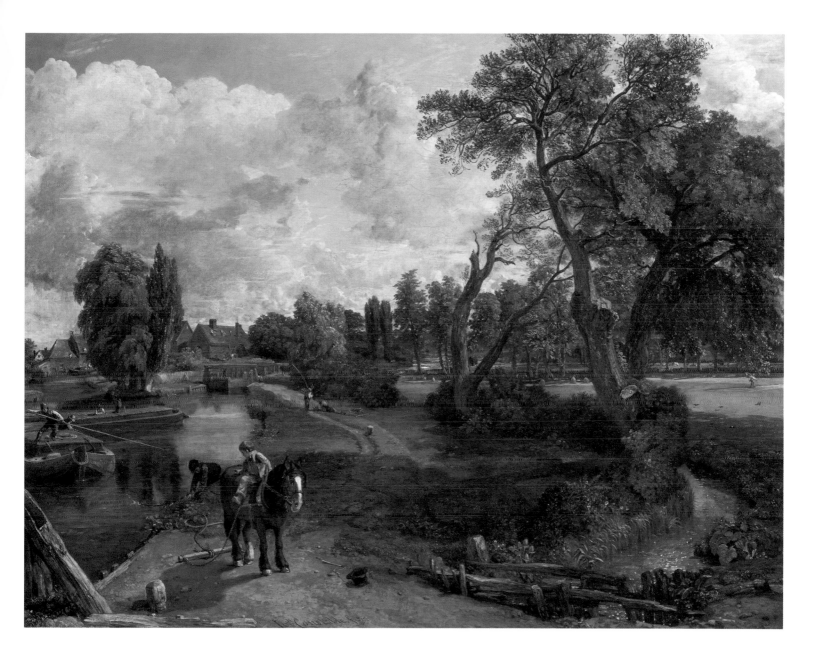

27. *Flatford Mill*, 1817,
Oil on canvas,
101.7 x 127 cm,
Tate Gallery, London.

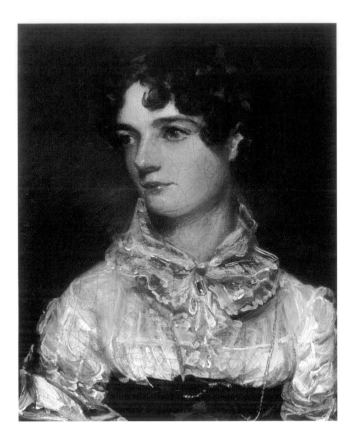

28. *Portrait of Maria*
Bicknell, Mrs John
Constable, 1816,
Oil on canvas,
30.1 x 25.1 cm,
Tate Gallery, London.

His remaining altarpieces, *Christ Blessing the Sacraments* (c. 1809, Nayland Church, Suffolk) and the *Risen Christ* (p. 50) (1822, Manningtree Church, Essex) are slightly more successful, but leave no doubt that biblical subjects were not Constable's forte. In Constable's work, overt or sustained symbolism of this type is much rarer, particularly in his early productions. It is found in his small painting of *A church porch*, which is a meditation on mortality and salvation, but the religious feelings and experiences he received from nature were often of a more general kind and thus difficult to express in pictorial terms.

To Constable, spring in East Bergholt, for example, evoked the Christian doctrine of the Resurrection. But visitors to the Royal Academy rarely looked for such sentiments in Constable's agricultural landscapes. By 1808, Constable was still unable to earn a living from his art, but he was well known at the Royal Academy. This situation, which had been thoroughly discouraging, became critical after 1809. In the summer of that year he returned to East Bergholt and fell in love with Maria Bicknell, whose father was solicitor

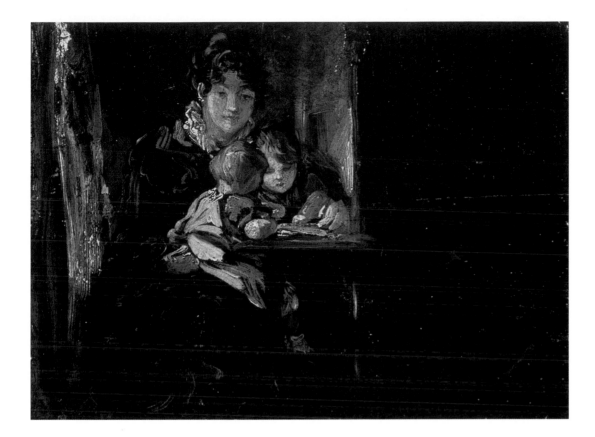

to the Admiralty, and whose grandfather was the Revd Dr Rhudde, Rector of East Bergholt and Brantham. Maria Bicknell had been brought up to expect a high standard of living and a certain social status. She thought it unlikely that they would manage on less than £400 a year, a sum that would represent great wealth to most, and was certainly beyond anything Constable could hope to secure. It is not surprising therefore that the Bicknell family were unhappy at having an unsuccessful painter as her suitor, or that they opposed the marriage for eight years.

His friend John Fisher knew that if Constable wished to marry Maria Bicknell, he would first have to achieve professional success and financial independence. To that end he began to concentrate with renewed ambition upon the canal and agricultural scenes that he later described as "my own places". One of the first manifestations of this was the large *Dedham Vale: Morning* (p. 21), shown at the Academy in 1811. It remained unsold, which augured badly for Constable's ambitions. In fact, Constable was not alone in this plight; Turner found it difficult to sell his oil paintings of agricultural subjects.

29. *Maria Constable with two of her Children*, c. 1820, Oil on wood, 16.5 x 22.1 cm, Tate Gallery, London.

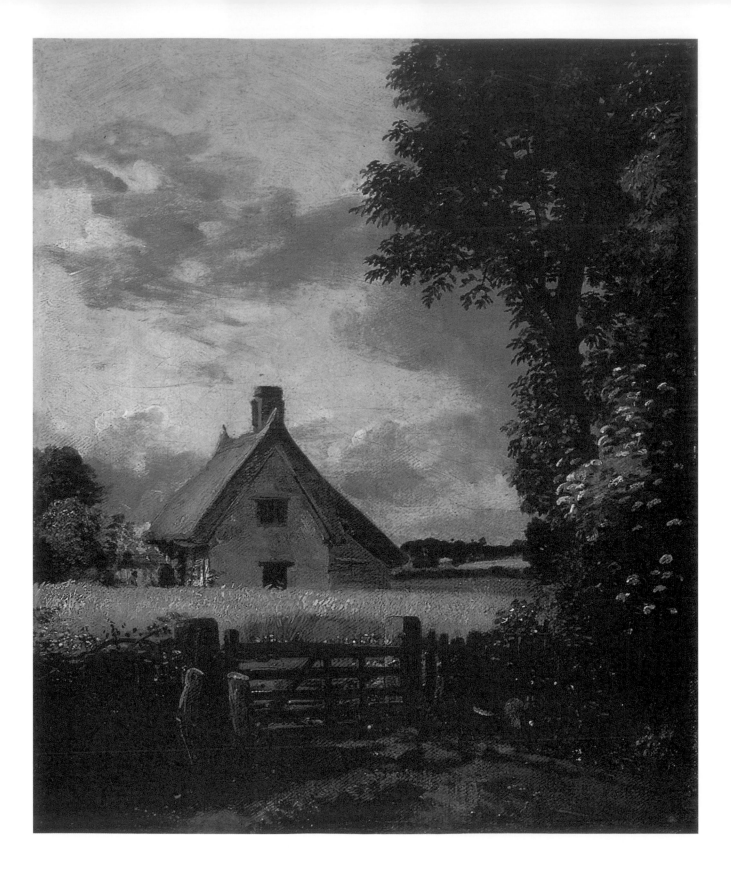

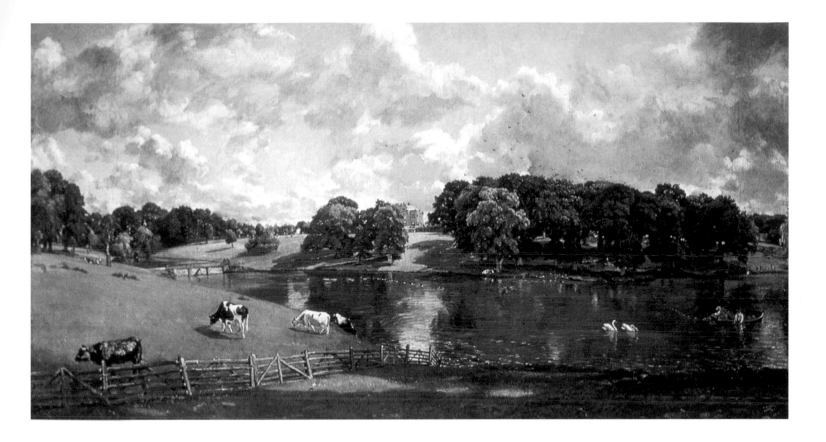

For Constable, whose family were directly involved as millers and corn merchants, these subjects would have had a greater personal significance, particularly since the war had driven up the price of corn and enhanced their prosperity. The farming scenes Constable painted between 1810 and 1820 are largely characterized by efficient methods and well-disciplined labour. Whilst he often worked on his paintings in oils before the motif, he also developed the habit of making small pencil sketches, sometimes of the landscape, but often of labourers at work.

Constable's sketches and figure studies served him as a repertoire of subjects and details, and two examples from a small sketchbook used in 1813 were employed in the composition of his *Ploughing Scene*. Most critics and visitors to the Royal Academy would not have appreciated the authentic details within this picture. Constable's agricultural scenes had a particular appeal to those with farming interests or experience, but unfortunately they were not always in a position to buy his pictures. The *Ploughing Scene* was an important painting for Constable. It found a purchaser in John Allnutt, a wine merchant from Clapham who had a model farm. It was also the first painting which he exhibited alongside a poetic text.

30. *A Cottage in a Cornfield*, 1816-1817, Oil on canvas, 31.5 x 26.5 cm, National Museums and Galleries of Wales, Cardiff.

31. *Wivenhoe Park*, 1816, Oil on canvas, 56.1 x 101.2 cm, Widener Collection, National Gallery of Art, Washington.

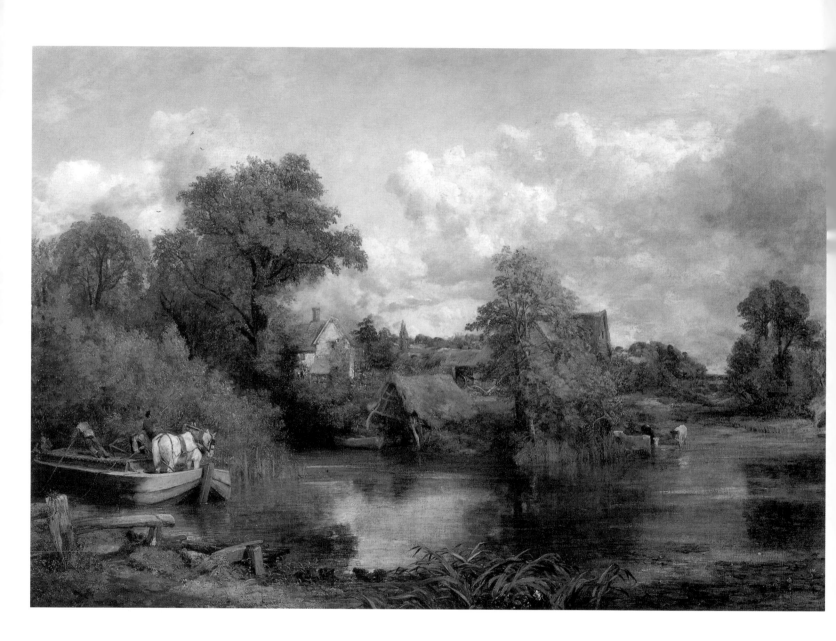

32. *The White Horse,* 1819,
 Oil on canvas,
 131.5 x 187.8 cm,
 Frick Collection, New York.

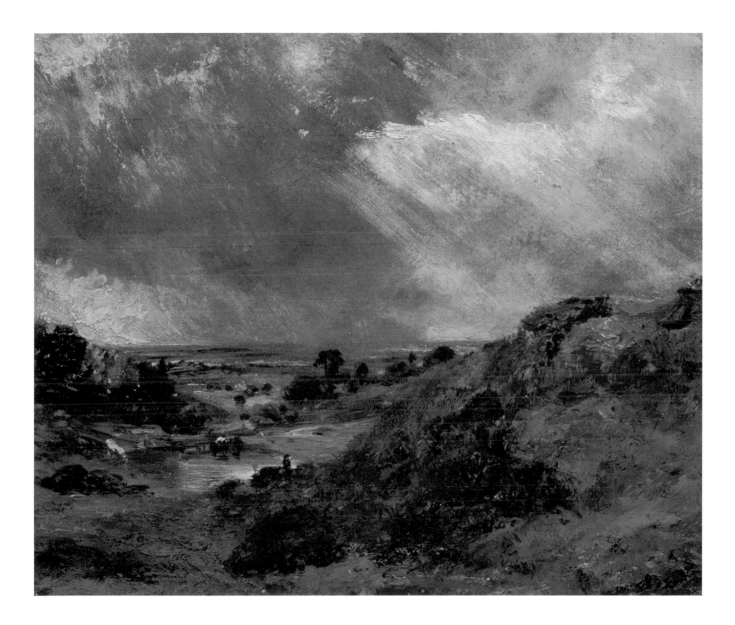

33. *Branch Hill Pond,*
Hampstead, 1819,
Oil on canvas,
25.4 x 30 cm, Victoria and
Albert Museum, London.

The entry in the Academy catalogue included two lines from *The Farmer's Boy* by the 'peasant poet' Robert Bloomfield: *"But unassisted through each toilsome day, With smiling brow the Plowman cleaves his way."* The phrase "smiling brow" has often been misunderstood, for it is a sign not of pleasure but of effort and concentration. Constable's mother was taken ill during a cold spell in March, 1815, and died at the end of the month. His father had been in ill health for some time, but his condition worsened and in December he collapsed. At first it appeared that his death was imminent, but he rallied and lived on until May, when he died peacefully in his chair.

Constable felt the deaths of his parents deeply, but they allowed him the financial independence he had been seeking. With a guaranteed income on that level he could finally contemplate marriage to Maria, although his new prosperity did not free him from the need to sell his work. They were, however, finally married by John Fisher at St Martin-in-the-Fields on 2 October, 1816. Maria's family did not attend the service. John Fisher, who had also married earlier in the year, invited them to spend their honeymoon with him and his wife Mary at Osmington in Dorset, where Fisher enjoyed one of his plural livings. Constable continued to work throughout their stay, carrying a sketchbook on the visits they made to Weymouth and Portland.

A number of impressive coastal scenes were produced in this way, including that of *Weymouth Bay* (p. 47). Like his other marine paintings *Harwich Light-House* (p. 55) and *Yarmouth Jetty*, he made multiple versions of some of his Osmington and Weymouth scenes, continuing to rework the material as late as 1824. On their return, Constable and his wife settled permanently in London, eventually renting a house in Keppel Street near the British Museum. After 1816, Constable, like other painters, turned away from realistic agrarian landscapes such as the *Ploughing Scene*, which had previously assumed such prominence in his output.

No single explanation can be offered for his change of direction. His marriage played an important part by removing him from East Bergholt; the depression and riots may possibly have alienated him and undermined his georgic ideals of farm labour; he may also have realized, as Christiana Payne has suggested, that most exhibition-goers, and some of his colleagues, regarded the subject-matter as commonplace and thus unlikely to gain him the recognition he needed. It was once remarked that if Constable had died when he was 40 years old, he would now be a comparatively minor figure within European painting. His fame, during and after his lifetime, was based in no small degree upon the series of six-foot paintings of scenes on the River Stour, shown between 1819 and 1825. These pictures represented a shift in emphasis in his work, inaugurated by *Flatford Mill* (p. 35) which he completed and exhibited in 1817.

34. *Cloud Study*, 1821,
Oil on paper on board,
24.7 x 30.2 cm,
Paul Mellon
Collection, Yale
Center for British Art,
New Haven.

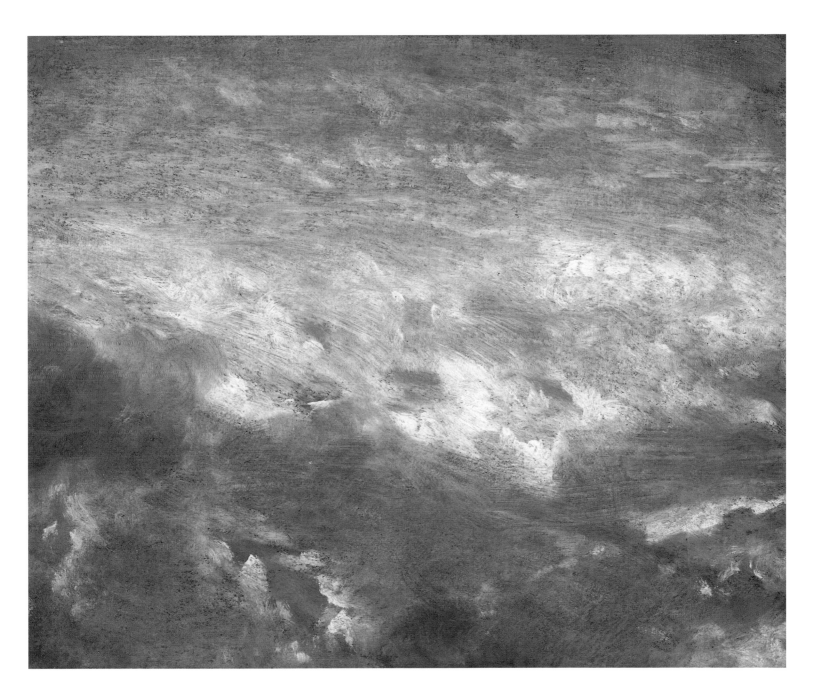

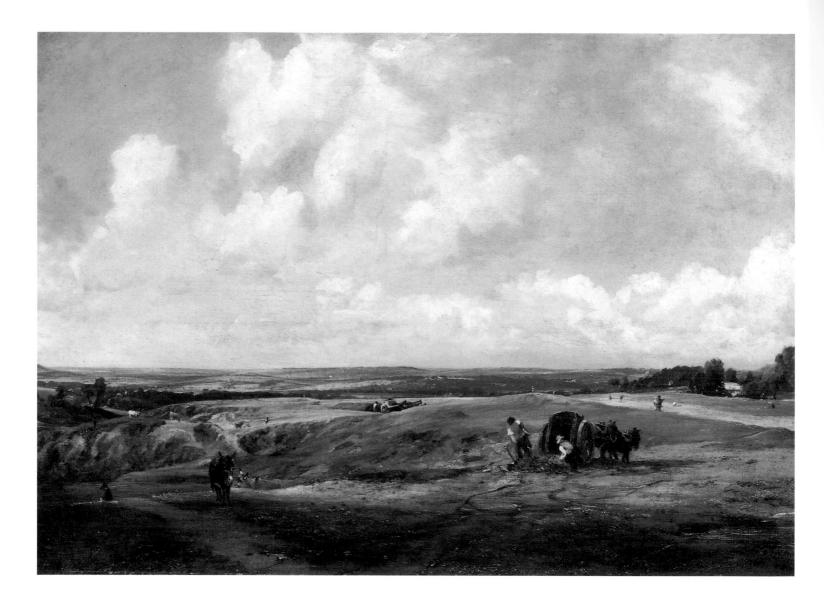

35. *Hampstead Heath*,
 c. 1820, Oil on canvas,
 54 x 76.9 cm,
 Fitzwilliam Museum,
 Cambridge.

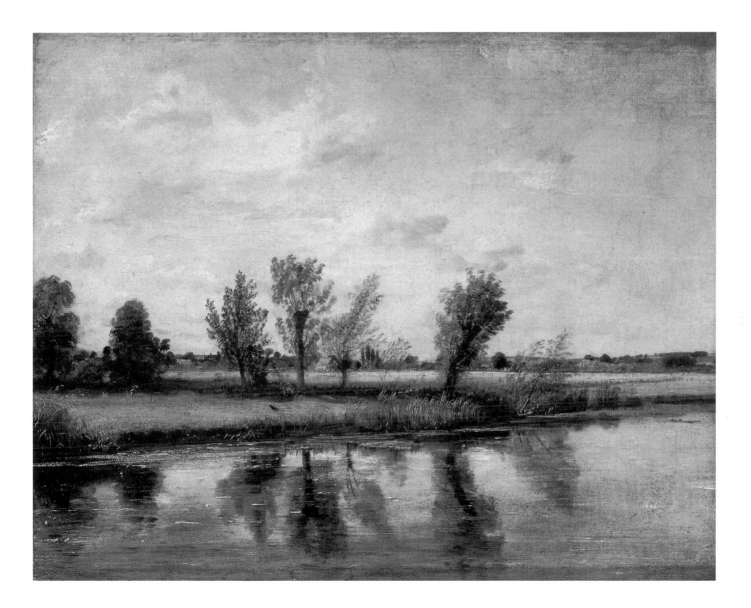

36. *Water meadows near
Salisbury,* 1820 or 1829,
Oil on canvas,
45.7 x 55.3 cm,
Victoria and Albert
Museum, London.

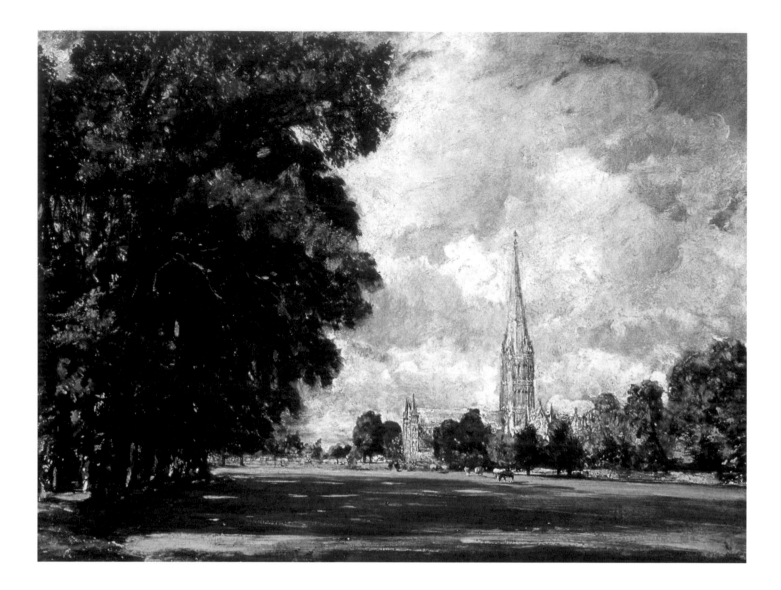

37. *Salisbury Cathedral from Lower Marsh Close,* 1820, Oil on canvas, 73 x 91 cm, National Gallery of Art, Washington DC.

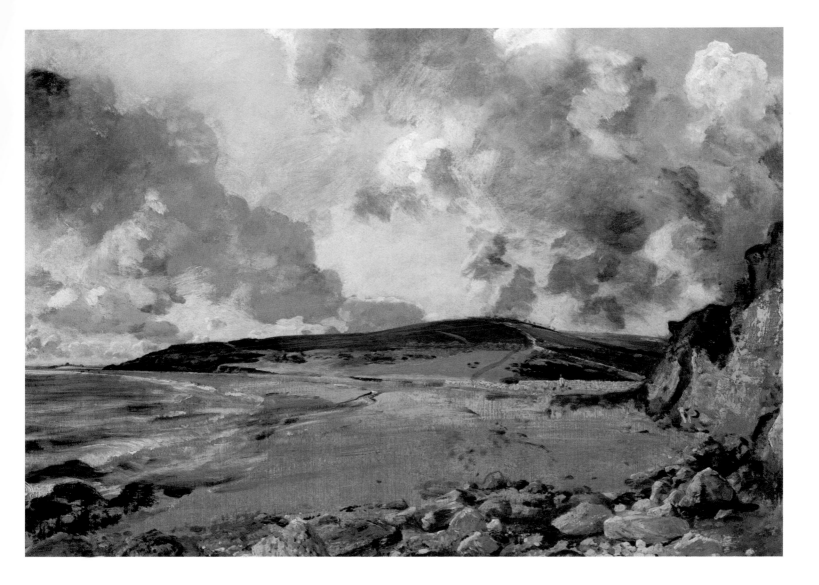

38. *Weymouth Bay*,
c. 1816,
Oil on canvas,
52.7 x 74.9 cm,
National Gallery,
London.

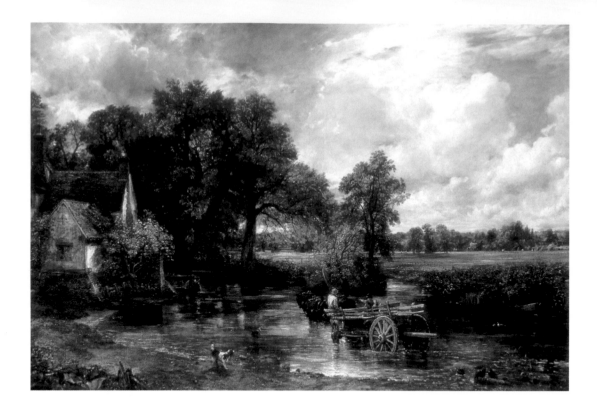

39. *Landscape: Noon (The Hay-Wain)*, 1821, Oil on canvas, 130.5 x 185.5 cm, National Gallery, London.

40. *Landscape with Goatherd and Goats* (copy after Claude Lorrain), c. 1823, Oil on canvas, 53.3 x 44.5 cm, Art Gallery of New South Wales, Sydney.

It was larger than much of his previous work, and distinctive enough for Farington to urge him to complete it for the exhibition, where it was widely noticed. Rumours eventually began to circulate about Constable's possible election to the Royal Academy and although the painting did not sell, he realized that another canal subject, on an even more ambitious scale, might consolidate his reputation. The *White Horse* (p. 40), the first to be painted on a six-foot canvas, was completed and exhibited in 1819, after a great deal of preparatory work.

It was not unusual to see six-foot landscapes at the Royal Academy, but they were generally of historical or 'elevated' subjects, and not the 'humbler' class of landscape to which the *White Horse* would typically be consigned. It therefore attracted more notice than any of his previous paintings, even though it had been poorly hung. There were some qualms about his handling, which had changed since he began to work extensively in the studio, but most of the comment was highly favourable. By 1819 domestic naturalism played a less important role in Turner's exhibited work and it was no longer possible to compare the artists in the same terms. Robert Hunt's review recognizes this and identifies them as representatives of different tendencies in English landscape painting.

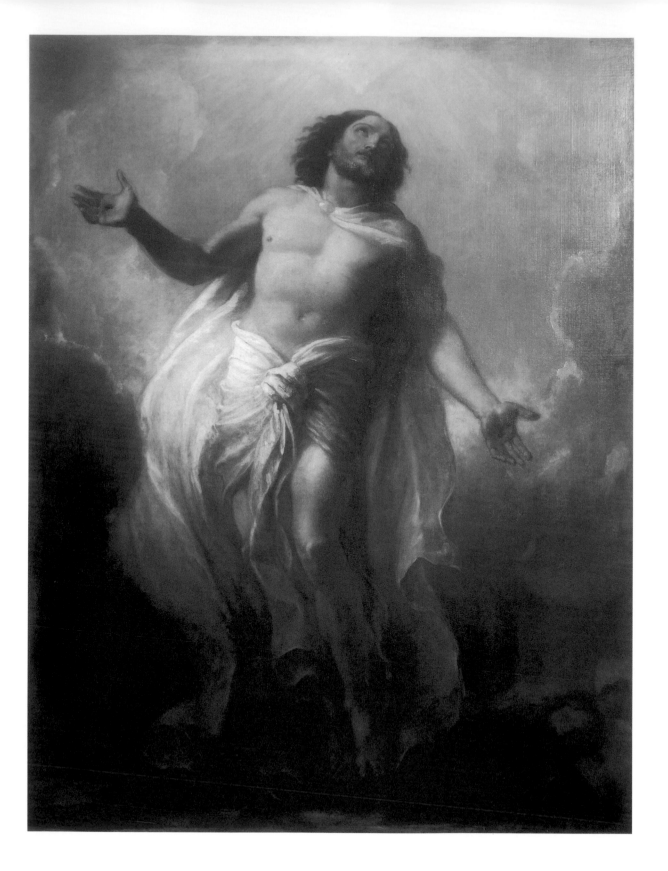

The White Horse compelled the Academy to take Constable's pretensions seriously, and he was finally elected an Associate on November 1, 1819, defeating the man who was to become his biographer, C. R. Leslie, by eight votes to five. This recognition was long overdue, and it represented a vindication of all his efforts and greatly enhanced his status. Their new prosperity allowed the Constables to rent Albion Cottage in Hampstead and thus to spend part of the summer living outside London, whilst still retaining a house and studio in the city. The heathland scenery was in marked contrast to that of his Suffolk pictures, but Constable explored its topography continually in the ensuing years.

The earliest known Hampstead painting is the small oil of *Branch Hill Pond* (p. 41) which was part of his initial exploratory work. In 1821, when he was confident enough, he began to show Hampstead scenes at the Royal Academy, where they kept company with his large-scale river, Stour subjects. He repeated the success of *The White Horse* with *Stratford Mill*, which was shown at the Academy in 1820. Apart from the barge moored on the far bank of the river there is little in Constable's picture to suggest that the mill at Stratford St Mary was a busy location involved in the manufacture of paper. Instead of depicting the working life of the Stour, he sought to guarantee public approval by introducing the young fishermen as a pleasing anecdote.

His ploy worked, since the paintings attracted attention and comment. Constable began work upon the *Hay-Wain*. This, the most popular of Constable's paintings today, was a variation upon the *Mill Stream* (p. 24) which he had painted in about 1814. Both pictures are of Flatford, where Constable's family moved after the sale of their parental home. In the *Hay-Wain* he adapts his vantage point in order to include not only Willy Lott's cottage and the stream which fed the family mill, but also the view across the Stour into the fields beyond. Here Constable reintroduces the kind of agricultural details found in pictures like the *View of Dedham* (p. 29) or those of his father's gardens, but because they are placed in the background they are legible without compromising the picture's wider appeal.

He was hard pushed to complete the picture in time for the exhibition of 1821. When the exhibition opened there were some quibbles about its lack of finish, and Constable seems to have been a little disappointed by the mixed reception it received when compared with the great success of its predecessors. Contrary to his expectations, it also failed to find a purchaser. In 1821 he began work on another six-foot painting entitled *A View on the Sour near Dedham* (Henry E. Huntington Library and Art Gallery, San Marino), whilst simultaneously making a series of oil studies of the clouds and sky. He worked from locations on Hampstead Heath, sketching at different times of day and with varying weather conditions, often writing these details on the back of the painting.

41. *The Risen Christ*, 1822, Oil on canvas, 162.4 x 127 cm, The Constable Trust

42. Study for *Cumulus
Clouds*, 1822,
Oil on canvas,
30.5 x 49 cm,
Courtauld Institute
Galleries, London.

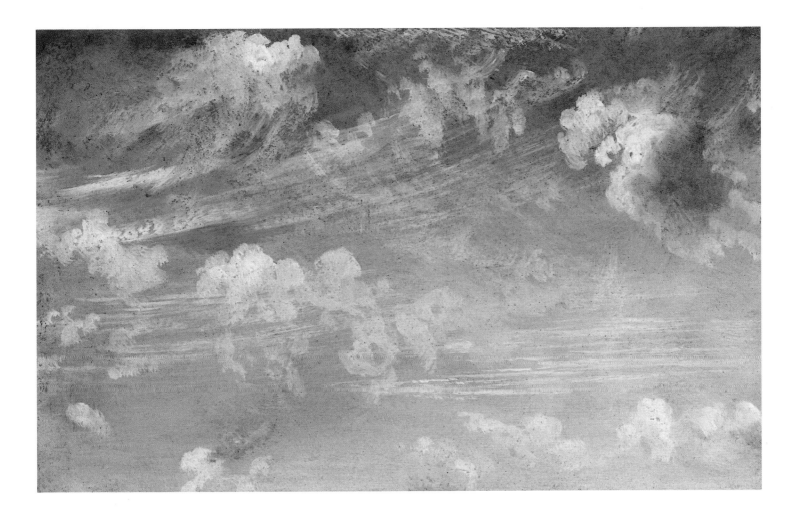

43. Study of *Cirrus
Clouds,* 1822,
Oil on paper,
11.4 x 17.8 cm,
Victoria and Albert
Museum, London.

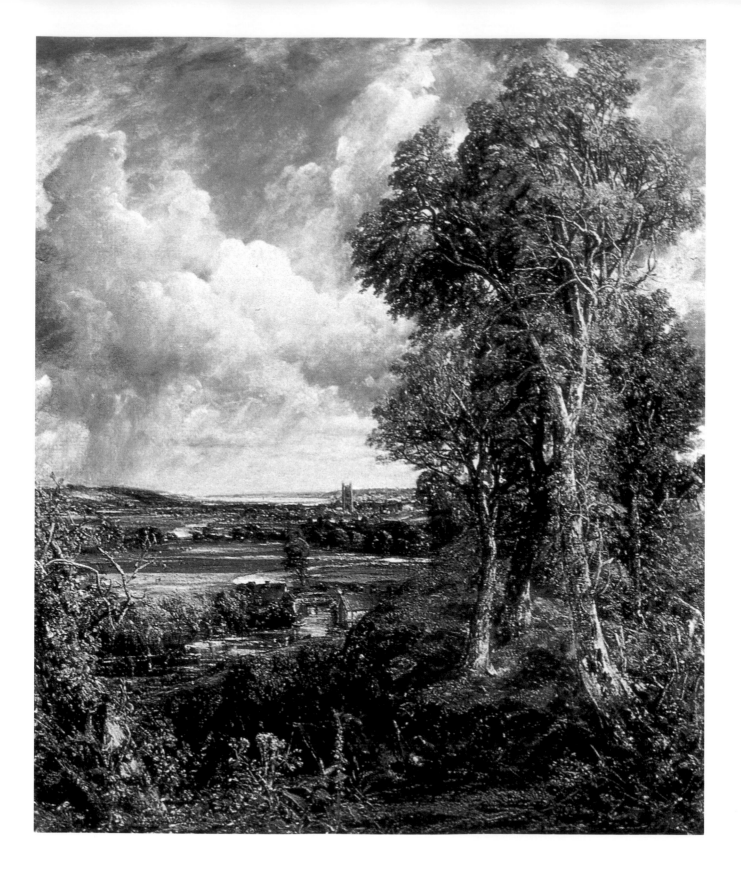

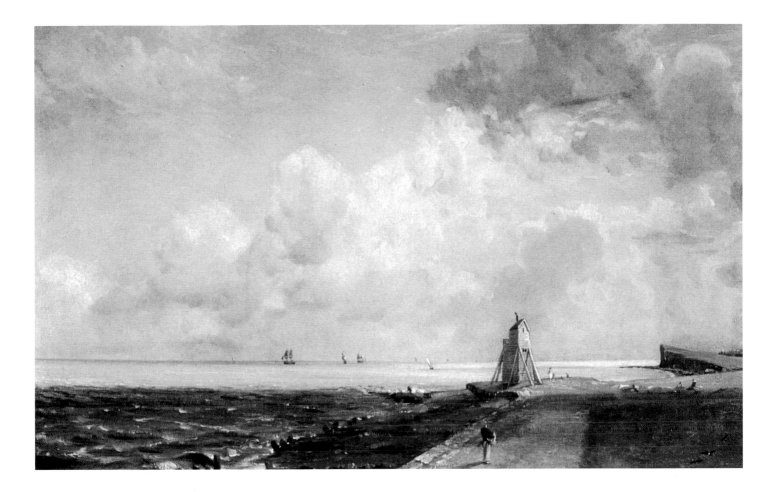

Constable had a long-standing interest in the weather and the skies, the sky determined not only the colour and chiaroscuro within a landscape, but also its expressive potential. It was the main means by which he would convey a mood, feelings or state of mind. In January, 1824, Constable was visited by a Parisian dealer, John Arrowsmith, who wanted to show his work in France. In the 1820s the antipathy expressed towards each other's art during the war by French and English painters was replaced by a period of great admiration for English art. The painter Theodore Géricault and the writer and traveller Charles Nodier were both struck by the *Hay-Wain* when they saw it at the Academy in 1821. Arrowsmith persuaded Constable to sell it, together with *A View on the Stour* and a version of *Yarmouth Jetty*, then duly showed them at the Paris Salon in 1824, where they were greeted with a loud chorus of praise from the likes of Stendhal (who doubted whether French Art had anything that would compare with them), Adolphe Thiers and Delacroix. Delacroix's reaction was important because he was an influential figure within French romantic painting.

44. *Dedham Vale*, 1823, Oil on canvas, 145.2 x 121.9 cm, National Galleries of Scotland, Edinburgh.

45. *Harwich Lighthouse*, c.1820, Oil on canvas, 32.7 x 50.2 cm, Tate Gallery, London.

He was still intrigued enough to visit Constable's London studio the following year, where they discussed certain aspects of the colouring in his landscapes. In the longer term, Delacroix may have passed his enthusiasm on to Theodore Rousseau, one of the landscape painters who worked at Barbizon in the Forest of Fontainebleau. Constable was proud of the celebrity he enjoyed in France, and of the Gold Medal he was awarded by King Charles X. Many of his pictures remained there and continued to exert an influence, but his French reputation must be seen in context. In the mid 1820s, English art was at the centre of a propaganda battle between conflicting styles. The younger painters such as Géricault and Delacroix, whom we now describe as 'romantic', admired the English bravura qualities of handling, colour and effect; but to those who upheld the neoclassical tradition of Jacques Louis David, English painting was a dangerous model to take.

To his warm reception in Paris was added a notable success at home. *The Lock* was shown to great critical acclaim and sold for 150 guineas to James Morrison, a successful draper, on the first day of the exhibition. The handling of the *Cornfield* is quite restrained, but for the most part Constable's brushwork is deliberately more emphatic in the major pictures exhibited after 1824.

In 1821 the *Hay-Wain* had been sent to the Academy in haste and lacking 'finish'; when it was shown in Paris three years later, Constable treated those same qualities as positive virtues. He was delighted when the Director of the Louvre had it re-hung to allow closer inspection, for "they then acknowledged the richness of the texture and the attention to the surface of objects". In *The Leaping Horse* (p. 62) he emphasizes its picturesque details such as 'old timber-props, water plants, willow stumps, sedges, old nets, etc.,' but places far less stress upon topographical accuracy by manipulating the details in the painting, shifting the willow stump and introducing Dedham church at a point where it would not actually be visible.

His primary concern was finding a way of conveying the sensations one might experience in the landscape, rather than solely presenting visual 'facts'. In 1824, Constable's pleasure as a result of his international fame was blighted by his wife's increasing ill health. Maria's sister and brother had both succumbed to tuberculosis and she began to display the same symptoms. Her doctor recommended a period of convalescence by the sea and so the family was moved to a house in the fashionable resort of Brighton, where Constable joined them whenever he could. On his visits he drew and sketched in oils, producing small but brilliant studies such as *Brighton Beach with Colliers* (p. 58). But on the whole he disliked the town. "Brighton", he wrote, "is the receptacle of the fashion of London. The magnificence of the sea, and its ... everlasting voice, is drowned by the din and lost in the tumult of stage coaches – gigs – 'flies' etc. –

46. *Salisbury Cathedral, from the Bishop's Grounds*, 1823, Oil on canvas, 87.6 x 111.8 cm, Victoria and Albert Museum, London.

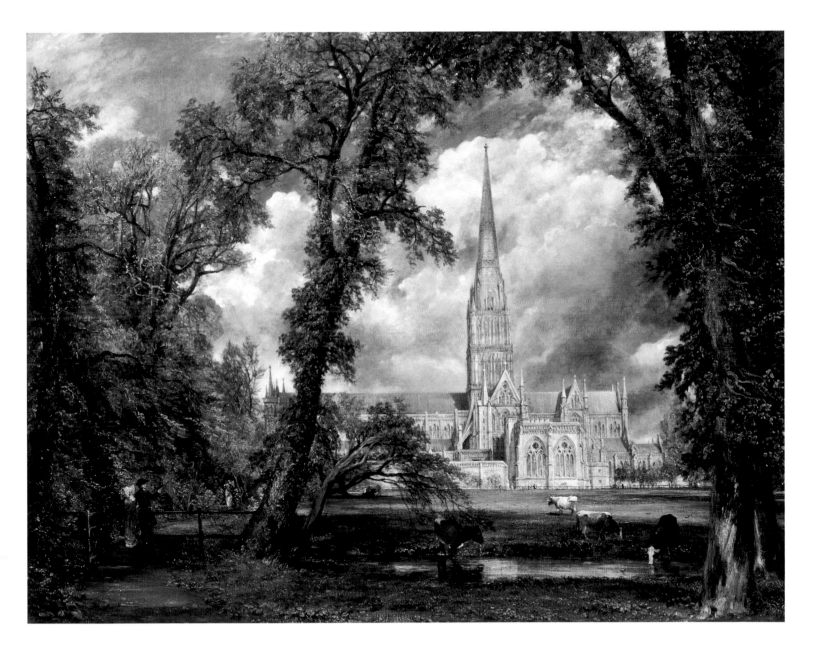

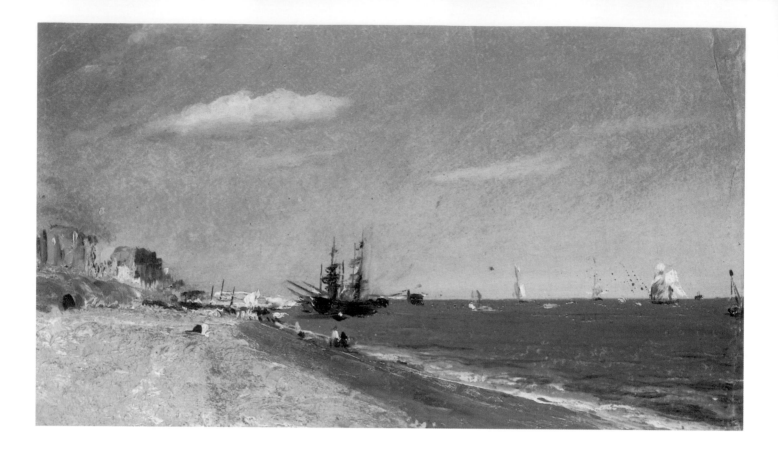

47. *Brighton Beach with Colliers*, 1824, Oil on paper, 14.9 x 24.8 cm, Victoria and Albert Museum, London.

48. *The Lock (A Boat Passing a Lock)*, 1824, Oil on canvas, 142 x 120.7 cm, Royal Academy of Arts, London.

and the beach is only Piccadilly by the seaside. In short there is nothing here for a painter but the breakers – and sky – which have been lovely indeed and always varying." In spite of his dislike for the place he eventually put his sketches to use in a large Brighton scene. When it was exhibited at the Royal Academy in 1827 the reviewer for *The Times* described him as "unquestionably the first landscape painter of the day," but others voiced criticisms over its colouring, and it failed once again to find a purchaser. This was partly due to Constable's uncompromising attitude to the subject. His painting defies conventional expectations by presenting Brighton less as a fashionable resort than as a fishing town. Constable's own health throughout this period was worsening. He was prey to rheumatism and to frequent bouts of anxiety and depression. In the same year, Maria's father died leaving her £20,000 which relieved all the financial difficulties they had suffered. But Maria's health was a cause of continuing concern. In spite of her tuberculosis she gave birth to their seventh child in January, but never fully recovered her strength. She grew steadily weaker throughout the year and died on November 23, 1828.

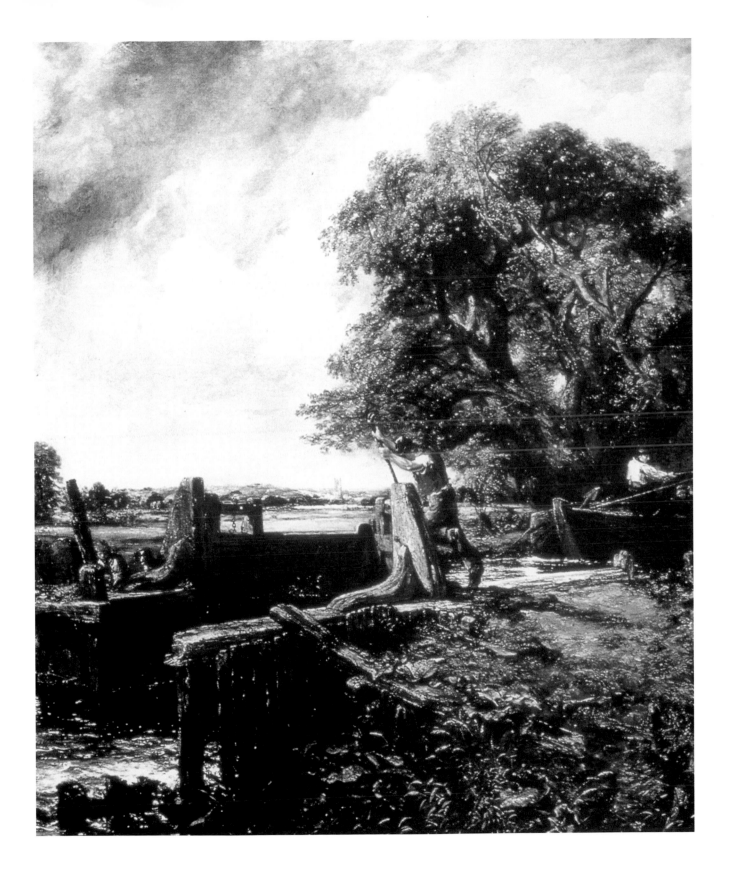

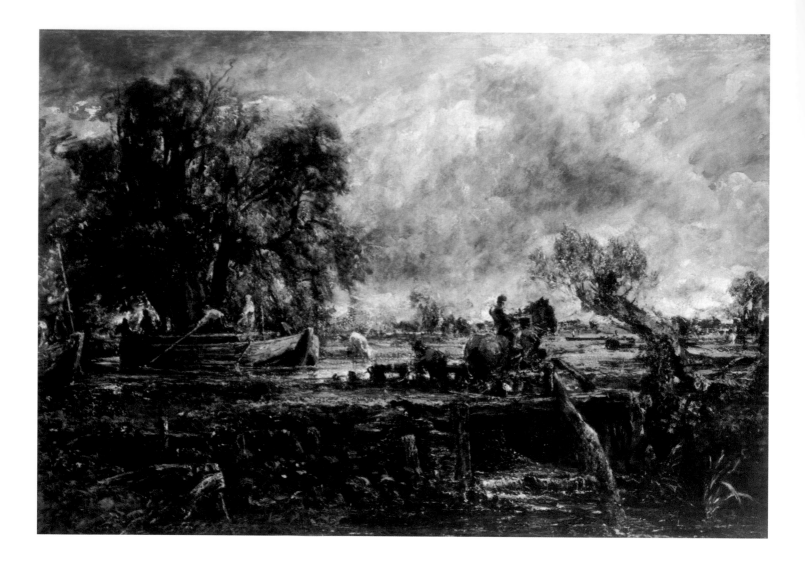

49. Full-Size Sketch for
The Leaping Horse,
1824-25, Oil on canvas,
129.4 x 188 cm,
Victoria and Albert
Museum, London.

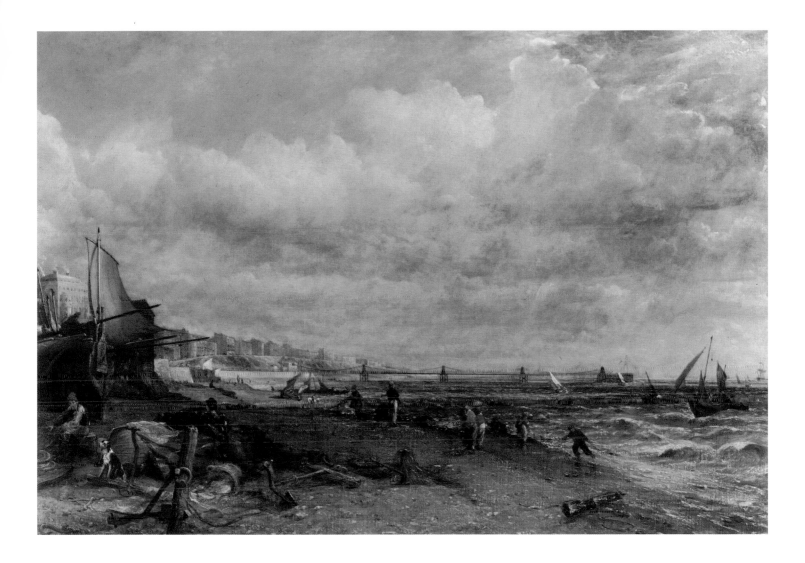

50. *The Chain Pier,*
Brighton, 1827,
Oil on canvas,
127 x 183 cm,
Tate Gallery, London.

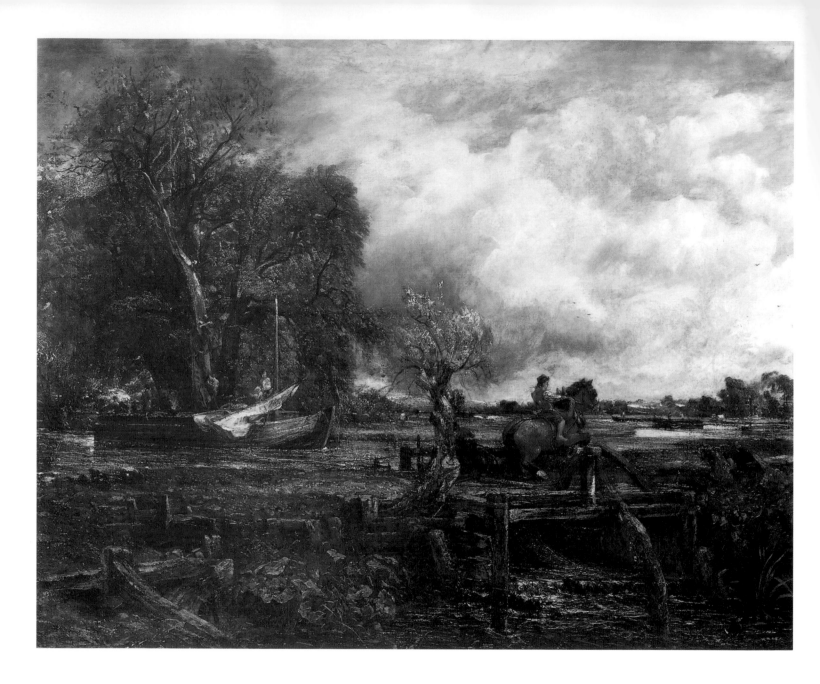

51. *The Leaping Horse,*
 1824-25, Oil on canvas,
 142.2 x 187.3 cm,
 Royal Academy of
 Arts, London.

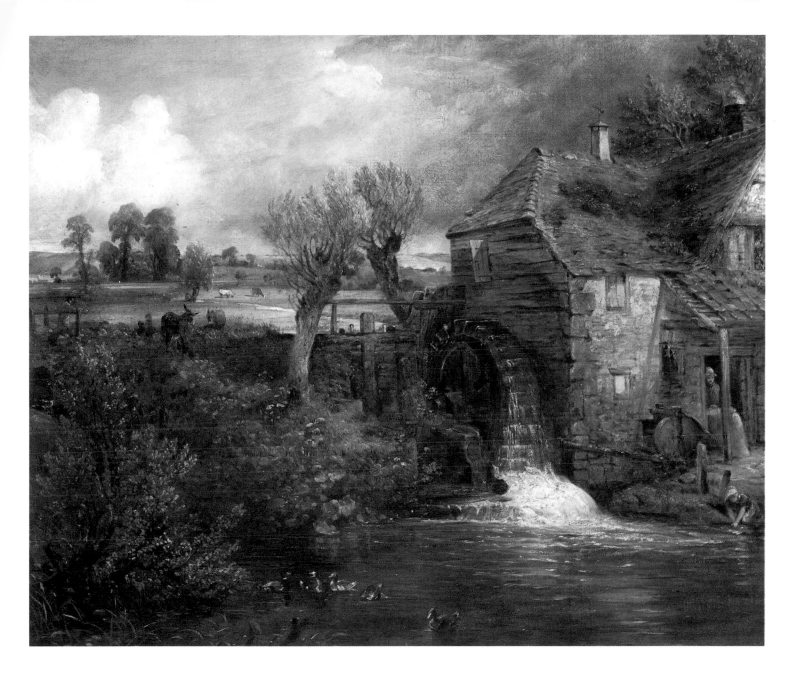

52. *A Mill at Gillingham in
Dorset (Parham's Mill),* 1826,
Oil on canvas, 50.2 x 60.3 cm,
Yale Center for British Art,
New Haven.

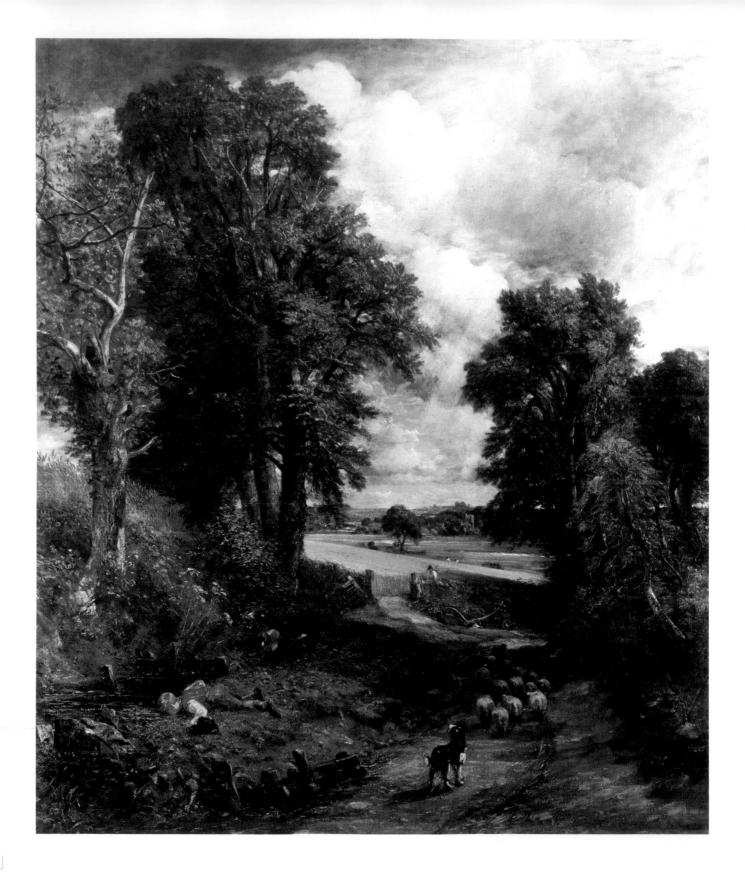

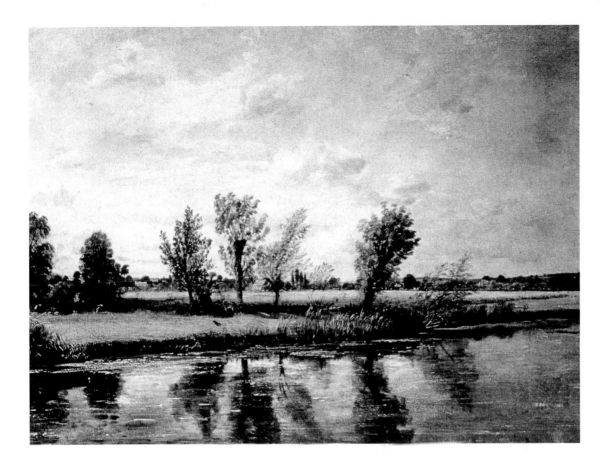

Constable was devastated and wrote to his friend, the portrait painter Pickersgill: "my loss, though long looked for, now it has come, has overwhelmed me, a void is made in my heart that can never again be filled in this world. My dear departed angel died in my arms on Sunday morning." The depth of his grief is often invoked to explain many of the stormier, more turbulent pictures of Constable's later years, like *Hadleigh Castle* or the small oil sketch of *Old Sarum* (p. 67). Constable was finally and belatedly elected a Royal Academician on February 10, 1829.

"It has been long delayed," he said, "until I am solitary and cannot impart it." Two months later he complained to Leslie that he was "still smarting" from his election and "in the height of agony" at the prospect of sending his picture of *Hadleigh Castle* to the exhibition. As a new Academician, his work would fall under close, often unfriendly scrutiny. He first sketched Hadleigh Castle, a remote and desolate location on the Thames estuary, in 1814. Constable's oppressive sky, which is more powerful in the full-size sketch than in the finished picture, may have expressed his feelings after Maria's death, but it was also consistent with the subject itself.

53. *The Cornfield*, 1826,
 Oil on canvas,
 143 x 122 cm,
 National Gallery,
 London.

54. *Landscape: A Study
 (Water-Meadows near
 Salisbury)*, 1829,
 Oil on canvas,
 45.7 x 55.3 cm,
 Victoria and Albert
 Museum, London.

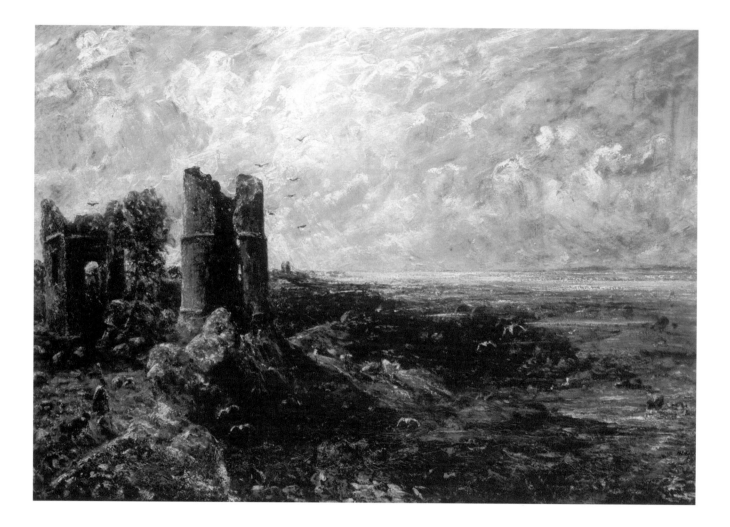

55. Full-size Sketch for
Hadleigh Castle,
c. 1828-29,
Oil on canvas,
122.5 x 167.5 cm,
Tate Gallery, London.

In 1821, when he described the sky as the "chief organ of sentiment", he was referring not merely to the artist's own emotions, but also to the associations of the place depicted. In the text accompanying the engraving of *Old Sarum* he wrote that "sudden and abrupt appearances of light, thunder clouds, wild autumnal evenings... even conflicts of the elements are appropriate to heighten, if possible, the sentiment which belongs to a subject so awful and impressive". In the last years of his life, Constable became more concerned than ever to demonstrate the versatility, seriousness and expressive potential of his chosen art. He feared that his pictures alone would not accomplish this and decided in 1829 to issue a series of engravings after his works with an accompanying explanatory text entitled *Various Subjects of Landscape, Characteristic of English Scenery, From Pictures painted by John Constable, R. A.*

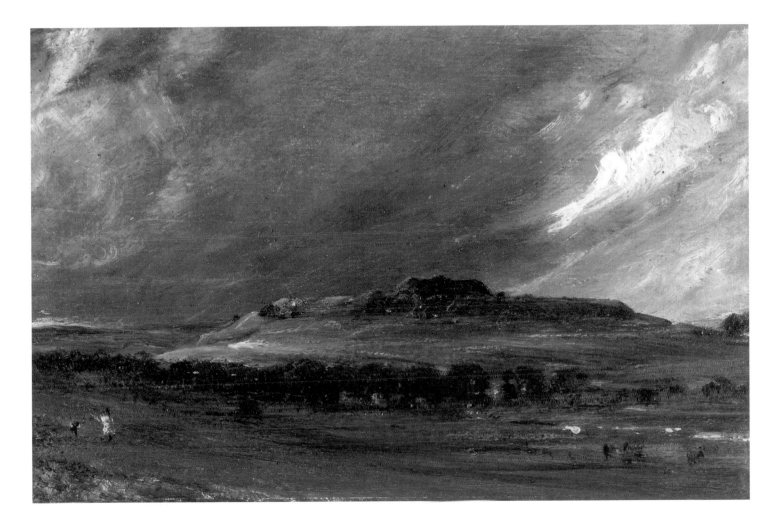

He invested a great deal of time, money and energy in the scheme, exercising the closest possible control over his engraver, David Lucas. Nonetheless, only twenty-two prints were issued during his lifetime and the public response was negligible. It may have met with indifference from most of his contemporaries, but the *English Landscape* series is an invaluable guide to Constable's later attitudes and intentions. In spite of his election to the Academy, Constable's achievements continued to go largely unrecognized. He even witnessed the supposedly accidental rejection of his *Water-Meadows near Salisbury* (p. 65) by the organizing committee of the annual exhibition. He was frequently plagued with poor health and in 1832 his rheumatism made it difficult to work on a large canvas. He may therefore have chosen to exhibit *The Opening of Waterloo Bridge* (p. 74) at the Academy because it had been under way for many years and required little finishing.

56. *Old Sarum*, 1829,
Oil on card,
14.3 x 21 cm,
Victoria and Albert
Museum, London.

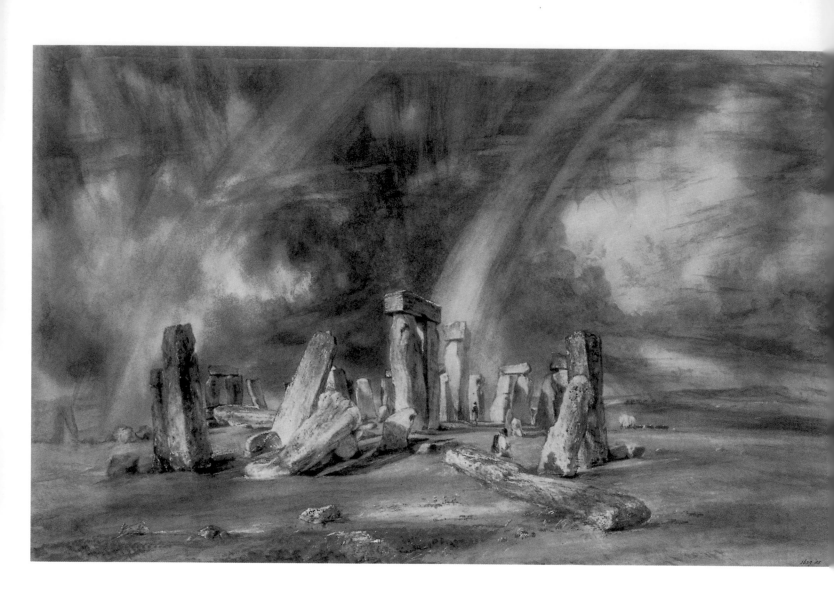

57. *Stonehenge,* 1835,
 Watercolour,
 38.7 x 59.1 cm,
 Victoria and Albert
 Museum, London.

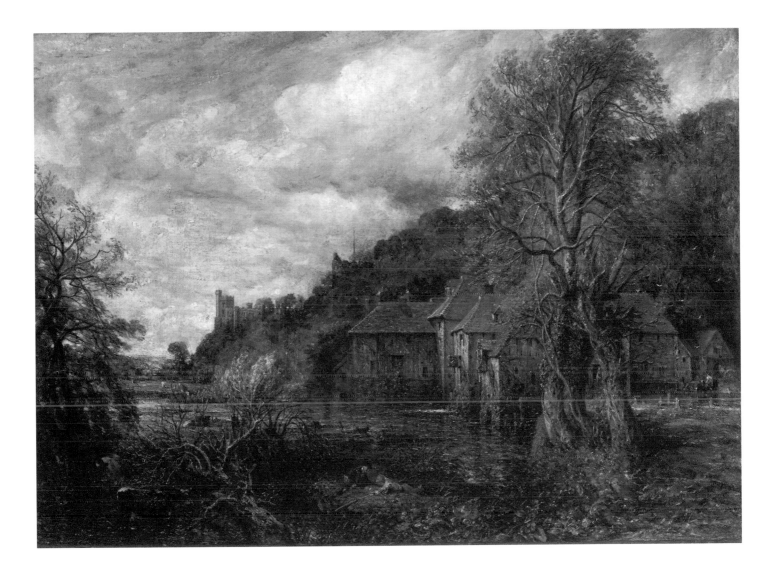

58. *Arundel Mill and
Castle,* 1837,
Oil on canvas,
72.4 x 100.3 cm,
Toledo Museum of Art.

He worked largely with the palette knife which was less painful to hold and manipulate than a brush. A twentieth-century audience, used to a lively paint surface, is more prepared to see the virtues in Constable's handling, even if they are virtues which arose in this case partly from necessity. Constable's need to communicate his purposes to an audience that had so consistently misunderstood him survived the fiasco of the *English Landscape* scheme.

Between 1833 and 1836, he delivered ten lectures on the history and theory of landscape painting at Hampstead, Worcester and the Royal Institution. *The Cenotaph* (p. 79) is a painting that is both didactic and valedictory. By taking Sir George Beaumont's memorial to his friend Reynolds as a subject, he could combine their names in the catalogue of the last Royal Academy exhibition to be held in Somerset House. It is a public tribute to the part they played in fostering and encouraging the British School of painting.

He flanks the cenotaph itself with non-existent busts of Raphael and Michelangelo, the artists to whom Reynolds repeatedly appealed in his *Discourses* as models of the 'Grand Style' in art. The meanings imparted by the painting are impeccable in their dignity and complexity, but they are delivered by means of landscape, a supposedly inferior genre. Constable celebrates the British School, but in a way that leaves no doubt about the centrality of landscape in any account of its achievements.

On another level the picture discharges a personal debt of gratitude to Reynolds and Beaumont, both of whom had materially shaped his career. He was still working on the painting on 3rd March, the day of his death. Although he had suffered ill health for many years, his death was unexpected and, from Leslie's account, all the indications are that he died of a heart attack.

Leslie immediately took charge of Constable's affairs and looked after the interests of his family. Leslie began to collect material for his biography, sifting through Constable's notes and correspondence and canvassing widely for reminiscences. He also provided an explanatory framework with which to approach the paintings and encouraged the growth of Constable's reputation.

59. *Salisbury Cathedral, from the Meadows,* 1831, Oil on canvas, 151.8 x 189.9 cm, Private collection, on loan to the National Gallery, London.

Constable now has no shortage of admirers and commentators, and towards the end of his life, he seems to have been resigned to such posthumous fame, as he explained in the introduction to *English Landscape:* "the rise of an artist in a sphere of his own must almost certainly be delayed; it is to time generally that the justness of his claims to a lasting reputation will be left; so few appreciate any deviation from a beaten track." He would have been gratified to learn that his words were prophetic.

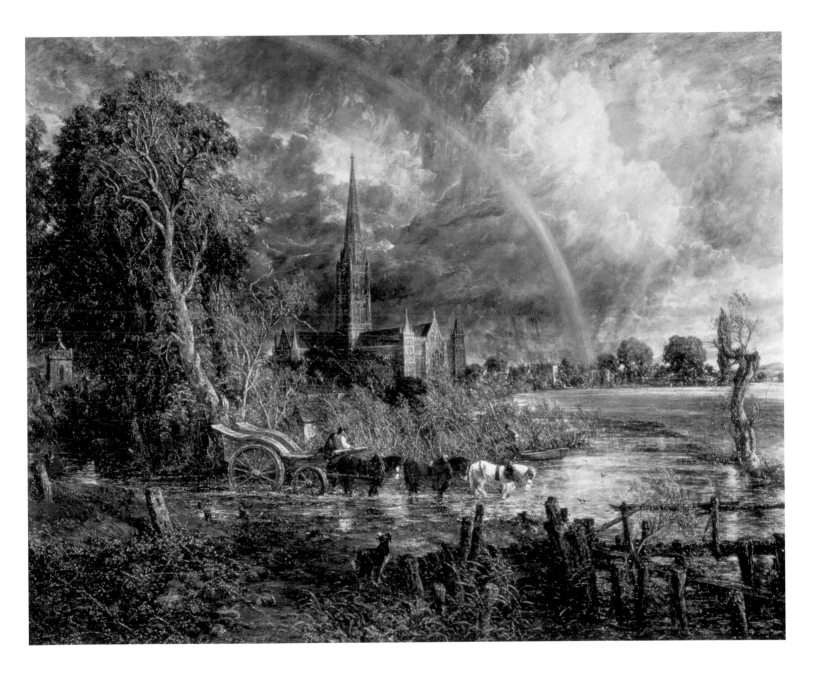

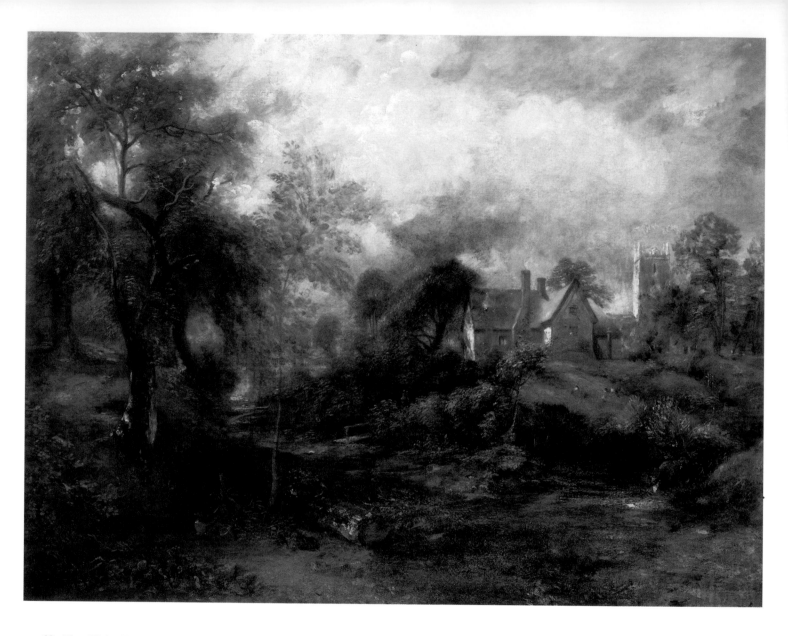

60. *The Glebe Farm*, c. 1830,
 Oil on canvas,
 65.1 x 95.6 cm,
 Tate Gallery, London.

61. *The Valley Farm*, 1835,
 Oil on canvas,
 147.3 x 125 cm,
 Tate Gallery, London.

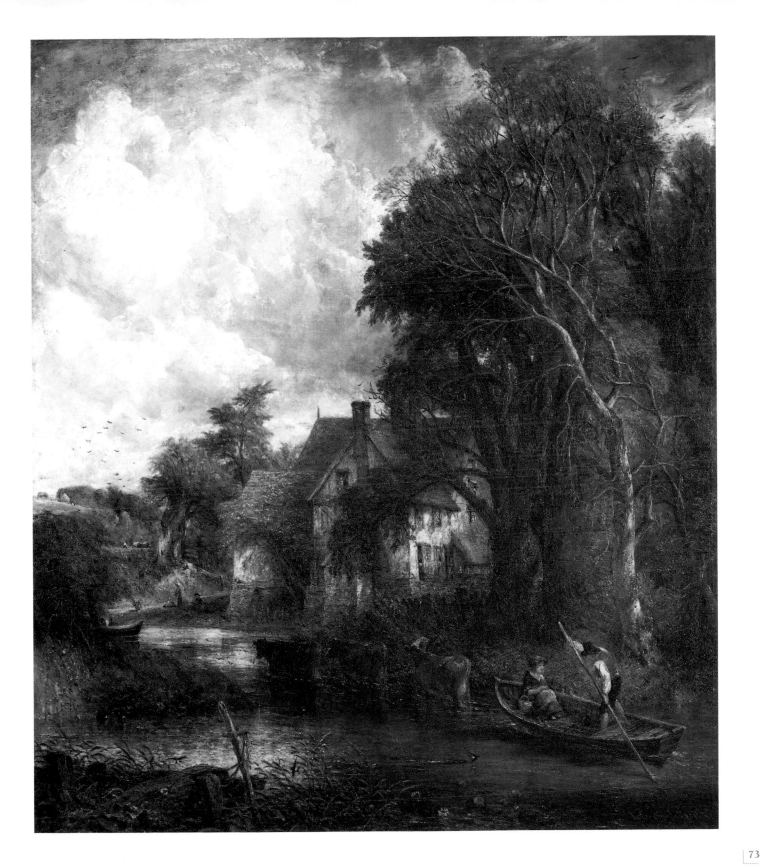

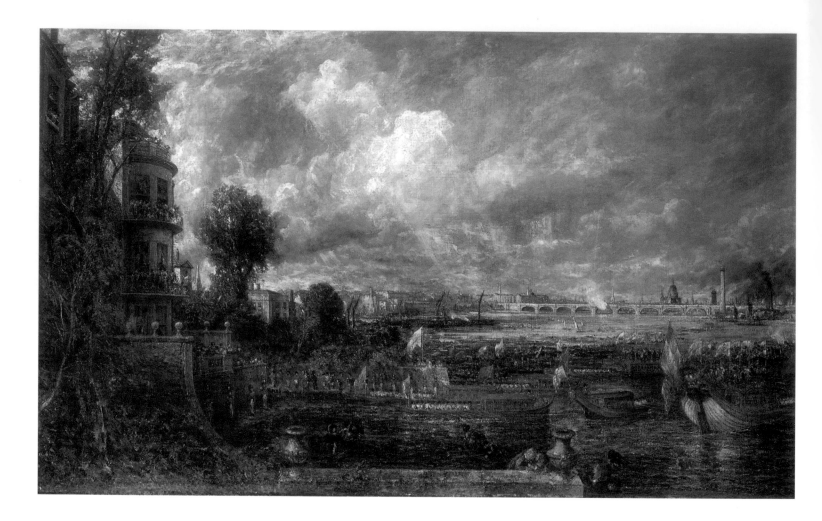

62. *Whitehall Stairs, June
 18th, 1817 (The Opening
 of Waterloo Bridge)*,
 1832, Oil on canvas,
 134.6 x 219.7 cm,
 Tate Gallery, London.

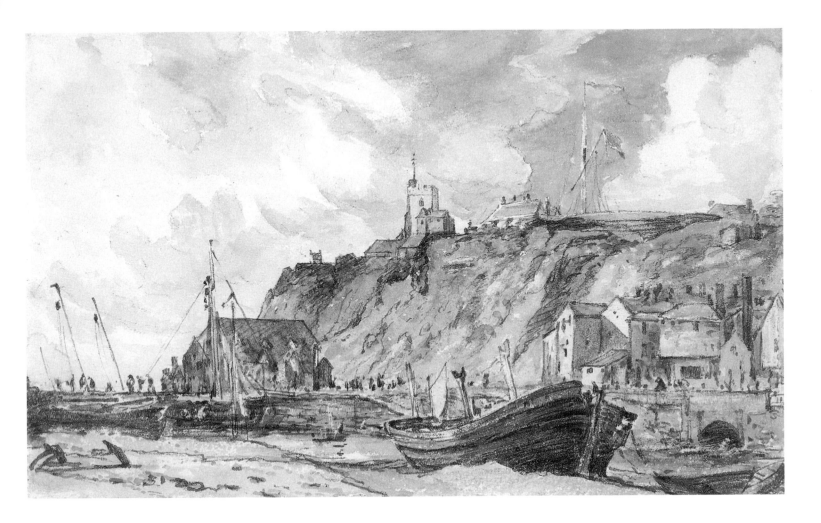

63. *Folkestone: The
harbour*, 1833,
Watercolour and
pencil, 12.7 x 21.6 cm,
Fitzwilliam Museum,
Cambridge.

BIOGRAPHY

1776: Born in East Bergholt, Suffolk, the fourth child of Ann and Golding Constable.

1783: Sent to school at Ford Street, Essex, thence to Lavenham and finally to Dedham Grammar School.

1793: Begins training as a miller. Paints in his spare time with John Dunthorne.

1795: Constable is introduced to Sir George Beaumont.

1796: Stays with relations at Edmonton where he meets J. T. 'Antiquity' Smith and John Cranch.

1798: Introduced to Dr John Fisher, later Bishop of Salisbury.

1799: Goes to London with a letter of introduction to Joseph Farington. Admitted as a probationer to the Royal Academy Schools.

1800: Copies works by Wilson, Ruysdael, Caracci and Claude.

1801: Tours and sketches in Derbyshire.

1802: Exhibits for the first time at the Royal Academy exhibition. Declines a post as a military drawing master.

1803: Journeys from London to Deal in the East Indiaman *Coutts*.

1804: Paints portraits of local Suffolk farmers. Sees Ruben's famous *Chateau de Steen* landscape in Benjamin West's studio.

1805: Commissioned to paint *Christ Blessing the Children* for Brantham church.

1806: Tours the Lake District, including Ambleside and Lake Windermere, Borrowdale and Langdale.

1807: Copies portraits by Reynolds and Hoppner for the Dysart family.

1808: Visits Dr Monro, patron of Cozens, Girtin, Turner and younger British artists. Becomes friendly with the celebrated genre-painter, David Wilkie.

1809: Spends August through to December in East Bergholt where he falls in love with Maria Bicknell.

1811: Meets the Revd John Fisher, who becomes his closest friend.

1812: Divides his time between London and Suffolk.

1813: Seated beside Turner at the Royal Academy dinner. July-October: fills a small sketchbook with pencil drawings from nature.

1814: Visits Southend and Fladleigh Castle. July: studies the Angerstein Claudes to improve his finishing.

1815: Death of his mother.

1816: Unrest in East Bergholt over the enclosure of the common. Death of Constable's father. August-September: stays at Wivenhoe Park, Essex. October: marries Maria Bicknell; they honeymoon with the Fishers at Osmington, Dorset.

64. *Trees and a Sketch of Water on the Stour*, c. 1831-36, Pencil and sepia wash, 20.3 x 16.2 cm, Victoria and Albert Museum, London.

1817: Summer: ten weeks at East Bergholt, his last long holiday in Suffolk. December: birth of his first child, John Charles.

1819: Finishes and exhibits *The White Horse*. July: birth of his second child, Maria Louise (Minna). Rents Albion Cottage, Upper Heath, Hampstead. November: elected Associate of the Royal Academy.

1820: Finishes and exhibits *Stratford Mill*.

1821: Exhibits *The Hay-Wain* at the Royal Academy. March: birth of his third child, Charles Golding. Studies the skies intensively.

1822: Serious agrarian unrest in Suffolk. The *View on the Stour near Dedham* exhibited at the Royal Academy. August: birth of Isabel Constable.

1823: October-November: with Sir George Beaumont at Coleorton Flail, Leicestershire.

1824: May-November: his family at Brighton for Maria's health; Constable joins them intermittently. *The Hay-Wain, View on the Stour near Dedham* and *View of Hampstead* are shown at the Paris Salon. King Charles X awards him a Gold Medal.

1825: March: birth of Emily Constable.
May: *The Leaping Horse* well received at the Royal Academy. Becomes increasingly friendly with C. R. Leslie, his future biographer. Death of Sir George Beaumont. Settles permanently into 6, Well Walk, Hampstead.
September: sends *The Cornfield* to the Paris Salon.

1828: Birth of Lionel Bicknell Constable. November: Maria Constable dies of pulmonary tuberculosis.

1829: Elected Royal Academician. David Lucas begins mezzotints after Constable's works to be published as *English Landscape*.

1830: *Water-Meadows near Salisbury* appears incognito before the selectors of the Royal Academy exhibition and is rejected.

1831: January: instructs Royal Academy students in drawing from the model. Begins work upon *Salisbury Cathedral, from the Meadows*. Suffers from acute rheumatism.

1832: Completes and exhibits *Waterloo Bridge*.
August: death of John Fisher.

1833: Lectures to Hampstead Literary and Scientific Society.

1834: February: suffers rheumatic fever. July: visits George Constable at Arundel. September: a guest of the Earl of Egremont at Petworth.

1835: Lectures again at Hampstead and Worcester. July: at Arundel with George Constable.

1836: *The Cenotaph* is exhibited at the Royal Academy. Lectures on Landscape to the Royal Institution and at Hampstead.

1837: February: at work on *Arundel Mill and Castle*. 31 March: dies, possibly of a heart attack. Buried at Hampstead Parish Church.

65. *Cenotaph to the memory of Sir Joshua Reynolds, erected on the grounds of Coleorton Hall, Leicestershire, by the late Sir George Beaumont, Bart*, 1833-36,
Oil on canvas,
132 x 108.5 cm,
National Gallery,
London.

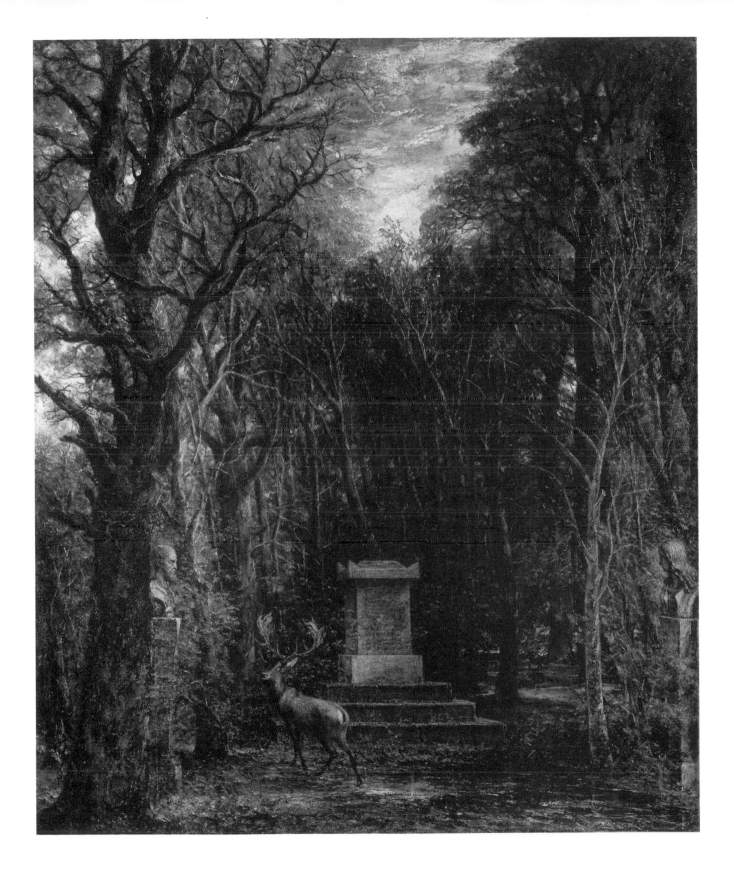

LIST OF ILLUSTRATIONS